P9-DEE-689

D0204406

THE DECADENTS

MASTERWORKS OF UKIYO-E

THE DECADENTS

後期浮世絵

by Jūzō Suzuki and Isaburō Oka

translation by John Bester

KODANSHA INTERNATIONAL LTD.
Tokyo, New York and San Francisco

Distributed in the United States by Kodansha International/
USA Ltd., through Harper & Row, Publishers, Inc., 10
East 53rd Street, New York, New York 10022.

Published by Kodansha International Ltd., 12-21, Otowa
2-chome, Bunkyo-ku, Tokyo 112 and Kodansha Interna-
tional/USA Ltd., 10 East 53rd Street, New York, New
York 10022 and 44 Montgomery Street, San Francisco,
California 94104. Copyright © 1969 by Kodansha Interna-
tional Ltd. All rights reserved. Printed in Japan.

LCC 69-16370
ISBN 0-87011-098-5
ISBN 4-7700-0079-0 (in Japan)

First edition, 1969
Sixth printing, 1982

Contents

ACKNOWLEDGEMENTS

The majority of the prints reproduced in this book are from the collection of Mr. Yoshiro Ōno and the publishers wish to express their special indebtedness to him. The remaining prints are courtesy of Messrs. Tōkichi Sakai, Kinosuke Hirose and Jūzō Suzuki.

Translator's Preface

THE prints reproduced here all date from the period, around the middle of the nineteenth century when the ukiyo-e went into its final decline. Chronologically, thus, this volume is the last in a series that begins in the mid-eighteenth century with Harunobu, originator of the polychrome print. In these pages, we witness the final flowering of the three main types of ukiyo-e print: the pictures of beautiful women; the actor-pictures that reached their peak with Sharaku; and the landscape, which only recently had been perfected by Hokusai and Hiroshige.

As Professor Oka suggests in the first section of the text, it is more appropriate in speaking of Kunisada, Kuniyoshi, and Eisen to refer to a "late flowering" than, as some writers do, to a "decadence." Admittedly, one does not need to look far in their work for signs of the fate soon to overcome the ukiyo-e: a certain artistic lifelessness combined at times with a contorted, almost violent quality, a preoccupation with clever composition for its own sake, and an interest in novel, peripheral effects in both subject matter and technique. In the work of the three artists represented here, however, these tendencies are still, for the most part, kept well in check. As one becomes familiar with it, their work is seen to be scarcely inferior to the best of what went before, and even to possess a special, ripe charm of its own.

The fact remains that this is the kind of ripeness that immediately precedes the rot; and in the years that intervened between the best of these three artists' work and the Meiji Restoration of 1868, the ukiyo-e, to all intents and purposes, died. It is interesting to speculate what would have happened to it if Japan had had another century of seclusion, or if the first steps towards Westernization had coincided with the heyday of an Utamaro or a Kiyonaga. But the answer is almost certainly that, as an art form, it would have died at any rate.

The development of the ukiyo-e depended to a high degree on the particular form of urban culture found in Edo of the seventeenth, eighteenth, and nineteenth centuries. Its public, though often referred to as "the common people," was limited and in some ways remarkably sophisticated. Thus when feudal barriers began to

break down and artists, engravers and printers found themselves catering to an ever wider public extending beyond the confines of Edo, a decline in standards inevitably set in. On top of this, the ukiyo-e was suddenly faced with a formidable set of rivals—in the printing techniques newly introduced from the West, in photography, and in new mass media as represented by the first true newspapers. Society itself began to change, offering countless new focuses for popular curiosity —a whole new world of brick buildings and bustles, oil paintings and antimacassars, alien ideas and foreign wars. For those members of the great public who hankered after art, there were new and more modish fields to be explored, while those who sought mere titillation could now look farther than their own theaters and brothels.

The success, in an urban society such as that of Edo, of a form at once so popular in its themes and so artistic in its execution as the ukiyo-e had been due to a fortunate coming-together of special circumstances. Now, the strange combination of sensitivity, sensationalism, and a highly localized brand of sophistication began to break down, with fatal results. The ukiyo-e's demise did not mean an end to all its traditions: there are still painters who trace their artistic pedigree to the ukiyo-e artists, and its influence persists within the general "Japanese" tradition of painting—not to mention modern Western painting. But there is little to link it with the more consciously "artistic" modern Japanese print apart from certain, in the broadest sense, Japanese qualities and a traditional skill in the particular medium. The ukiyo-e was a peculiarly Japanese art, perhaps, in that it thrived under severely restricting circumstances. Now, those circumstances have disappeared and the art itself is no more.

J. B.

The End of an Era

KUNISADA, Kuniyoshi, and Eisen, the three artists represented in this collection of ukiyo-e prints, were active for a period of approximately half a century beginning in the Bunka era (1804–1818). Though each has his own characteristics, they are all representative of the last days before the final collapse of the Tokugawa regime and the advent of the Meiji Restoration. Together, their work constitutes the last flowering of the ukiyo-e.

Once the great achievements of the Temmei (1781–1789) and Kansei (1789–1801) eras were past, the culture of Edo began to show increasing signs of decadence. The ukiyo-e did not escape this general decline. Having reached its peak in the last two decades of the eighteenth century with the work of Sharaku and Utamaro, it began to deteriorate in the Bunka and Bunsei eras, and the word "late" as applied to the ukiyo-e of the Bunka era and later has always been used as a term of disparagement. However, during this same period it is generally admitted that Hokusai and Hiroshige, by perfecting the landscape print, brought a new luster to the genre in its final stages. But where portraits of actors and *bijin-ga* (pictures of beautiful women)—those twin staples of the ukiyo-e—are concerned, most books on the subject, while giving brief mention to Toyokuni I, have almost totally neglected men such as Kunisada, Kuniyoshi and Eisen.

What is more, for all but a few people the term "late ukiyo-e" calls to mind a particular type of cloying, decadent, and vulgar print—the garishly colored, stereotyped actor portraits, the grisly murder scenes and the stylized, contorted pictures of women. It calls to mind, in other words, the ukiyo-e of the very last years before the Restoration.

In talking of the late Edo period, however, one should remember that there was a marked difference between the Bunka, Bunsei, and early Tempō eras on the one hand and the late Tempō, Kōka and Kaei eras that followed, with the Tempō reforms as a kind of dividing line. Even in the former period, the spirit of the age varied slightly from the Bunka to the Bunsei and Tempō eras and artistic styles varied correspondingly.

Unfortunately, since the amount of first-class work in the first half of the nineteenth century is small in proportion to the vast total output, all of it tends to be dismissed as "late," with the result that the peculiar beauty and interest of the work of the three artists represented here have been overlooked. This collection aims at correcting the injustice and providing a new outlook on the late ukiyo-e.

The period of fifty years or so during which Kunisada, Kuniyoshi, and Eisen were active saw Japan beset by difficulties both from without and from within. In the Bunka and Bunsei eras, during which Edo suffered no major conflagrations or major earthquakes, the influence of the preceding Kansei era still gave a certain relaxed air that is apparent in the art. However, Utamaro, who had been without peer in his day, died in 1806, and Kiyonaga's creative life was more or less over. But Utagawa Toyokuni was beginning to attract attention with his pictures of actors and *bijin-ga* and his pupils were also coming into their own; the ukiyo-e, in short, was beginning to pass into the hands of a new generation.

In the field of literature, the same period was the age of transition from the *kibyōshi*, popular novelettes with copious illustrations, to the *gōkanbon* (or *gōkan*), which were not so much illustrated stories as stories in pictures with the dialogue or text relegated to whatever blank spaces happened to be left. The readership of these works extended throughout the country, and some are said to have sold tens of thousands of copies. The ukiyo-e artists who did them varied their subject matter freely from tales of revenge to ghost stories to domestic dramas, depending on the fashion of the day; Kunisada, for instance, is said to have produced some four or five hundred such books. This nationwide popularization was a new phenomenon; it expanded the routes whereby published material—prints as well as books—reached the public, and since the authors were usually the illustrators as well, doubtless had an effect on the nature and quality of the ukiyo-e also.

The kabuki of the Bunka and Bunsei eras typified the decadent taste of the age in its liking for ghost stories, cruel tales of revenge and murder and heavily sentimental scenes, with an increasing emphasis on literalism. The same demand for realism is apparent in the ukiyo-e, where an emphasis on heavy colors and literalness of treatment begins to replace the early idealism. In the *bijin-ga*, for example, the lyrical romanticism of Harunobu, the pursuit of an ideal beauty seen in Utamaro, and the relaxed, graceful atmosphere common to both, are gradually replaced by the naturalistic depiction of actual women from the world of pleasure that the artists saw about them.

A feature common to all three artists is that they did not seek a simple ideal of feminine beauty as did earlier artists but consciously or otherwise created a special type of decadent, overripe beauty that faithfully reflected the quality of the world around them. The tall and graceful women of Kiyonaga and the relaxed and serene beauties of Utamaro are replaced by the almost hunchbacked figures, sagging at the knees, that became the hallmark of the late *bijin-ga*. One should

perhaps see these women less as a creation of the Utagawa school than as a more or less realistic portrayal of the women of the day, with the addition of a new, more sophisticated and more voluptuous sense of "style" *(iki)* that differed from the *iki* of the previous generation. It is probably symptomatic of social conditions at the end of the Tokugawa period, moreover, that the *bijin-ga* of this period shifted its focus of interest from the licensed, relatively "high class" Yoshiwara gay quarters to the poorer or unlicensed brothel areas.

The special quality of the culture of the late Edo period was of course closely bound up with the impasse reached by the policies of the Tokugawa Shogunate, and the collapse of its economic measures in particular. The inward-turning, frustrated, narcissistic quality of Edo merchant culture was turning sour, and neither the romantic escapism of, say, Harunobu, nor the sensuous idealization of Utamaro were any longer possible. Things went from bad to worse, but the government continued its frantic attempts to get society under control. The reforms inaugurated in 1841 by Mizuno Tadakuni were the most drastic since those of the Kyōhō and Kansei eras, and the provisions dealing with color prints, picture books and illustrated novelettes were extremely harsh. One quotation from the official decree will suffice: "The trash known as *nishiki-e*, depicting on single sheet prints kabuki actors, prostitutes and geisha are detrimental to public morals; henceforth, not only the production of new prints, but the buying and selling of existing stocks also, will be forbidden. . . ."

In addition to this, portraits of actors in illustrated books, as well as lavishly colored pictures of any description, were also prohibited, and those responsible were commanded to produce works that would encourage virtues such as loyalty, filial piety, and chastity and contribute to the moral welfare of women and children. Still other edicts restricted the number of colors permissible in a print and prohibited the portrayal of women other than young girls. Then at the end of the eleventh month of 1842 the old system of approval by an official censor was changed to a system whereby each work had to have the seal of the head of the local district—an attempt to make the censorship more responsible. Thus a vogue developed for what were ostensibly morally edifying or didactic works.

The edification in many cases, unfortunately, went no further than the titles, and a considerable number of these works were nothing more than thinly disguised *bijin-ga*. In many cases, the stern prohibitions merely gave practice in the gentle art of dissimulation. Technically, moreover, they stimulated a search for new types of elaboration to replace those that had incurred official disapproval. Thus much use was made of *aizuri* ("indigo printing," using the commonest type of blue pigment). The technique itself was old, but now several different blocks were used for the same color, producing subtle effects of light and dark, and a clean-cut effect that proved very popular in its day. Edict followed edict, but the production of *bijin-ga*, actor-pictures and the like continued in flagrant violation of them

all. So sadly had the shogunate's authority declined, in fact, that some artists—including Kunisada—even dared to satirize the shogunate itself.

In 1843 the departure from office of Lord Mizuno, author of the latest reforms, brought an end to attempts at reform, and enforcement of existing regulations became still more lax. Almost immediately the *nishiki-e* started making a recovery. Prints more richly colored and technically elaborate than ever began to be produced, and by 1846 the return to the old days was well under way.

One of the marked characteristics of the age is, in fact, the great technical elaboration of engraving and printing; techniques of engraving details such as fine hairs, for example, reached an astonishing level of proficiency. In its last years, however, the print shows an increasing preoccupation with technical brilliance for its own sake, and the artistic decline that has led some people to dismiss the late ukiyo-e as no more than a decorative art set in on a large scale.

This is the background against which our three artists lived and worked. They were a varied trio, despite the resemblances in their art. In 1844, Kunisada took the name of Toyokuni II. In doing so, however, he ignored the fact that following the death of his teacher Toyokuni I, Toyokuni's adopted son, Toyoshige (who is said to have died in the late 1830's) had already officially succeeded to the name, and he should properly have been known as Toyokuni II. Kunisada seems to have had a considerable degree of self-assurance, and a satirical poem of the day referred to him as the man who had "got himself the name of Utagawa by hook or by crook—Toyokuni the Second" (the Japanese contains a pun—the words for "the Second" and "the imposter" are pronounced in the same way). Other writers such as the novelist Shikitei Samba, however, described him as a mild man who in doing illustrations always worked dutifully from the author's rough sketches or according to his specifications. In all probability, he had a high regard for himself yet was too prudent to let it interfere with his career. In this respect he seems to have been the complete opposite of Kuniyoshi, who seems to have been unabashedly commercial with a volatile, difficult disposition. The rivalry between the two men, as we shall see later, was apparently strong enough to attract general notice. Kunisada, as Toyokuni II (III), became head of the Utagawa school, while Kuniyoshi became the idol of the print world for his pictures of warriors and his landscapes in particular, though he was also proficient at pictures of beautiful women and actors. Eisen, on the other hand, stood outside the Utagawa school to which these two men and Hiroshige belonged, founding his own school of landscape and *bijin-ga* to compete with them. He was also a writer of popular novelettes, and contributed to ukiyo-e studies with his *Mumei-ō Zuihitsu* ("Essays of a Nameless Old Man"), a revised version of the *Ukiyo-e Ruikō*, which has always been one of the main sources of information on the subject.

ISABURŌ OKA

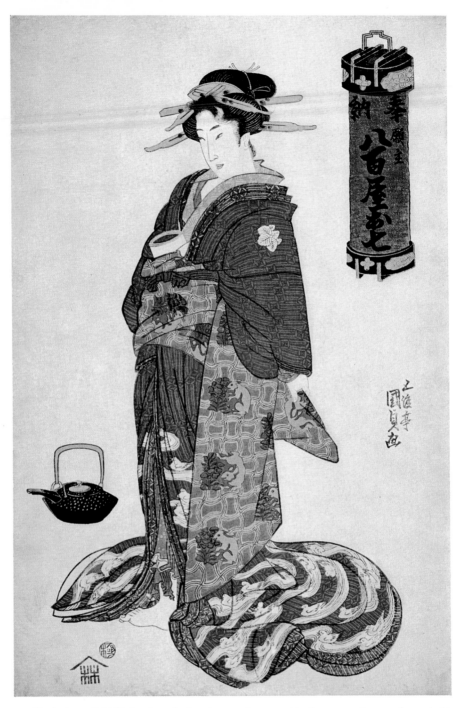

1. *Kunisada* ◆ *Oshichi the Grocer's Daughter, from "Presentation Lanterns"* ◆ *ōban* ◆ published by Iseya Rihei ◆ The prints in this series —each of which has, at the upper right, a lantern of the type presented by patrons to a theater, with the name of a popular Kabuki role—are of uniform excellence. This and a similar series, "Presentation Handtowels," are the two finest works of the period when Kunisada began using the pseudonym Gototei.

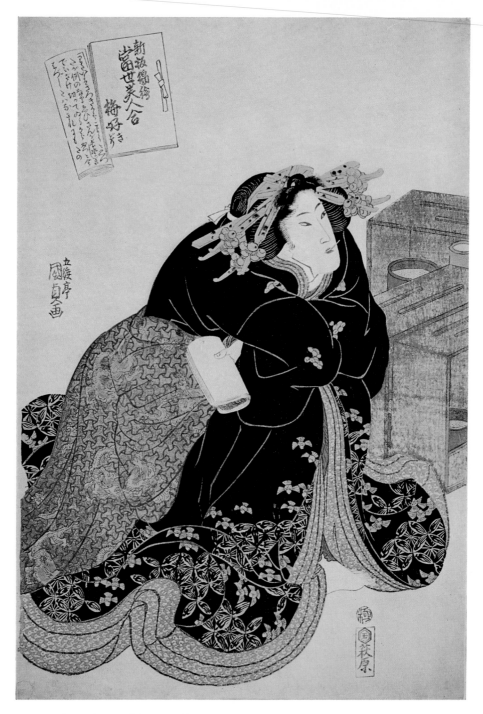

2. *Kunisada* ◆ *The Would-be Baikō, from "New Nishiki-e Contemporary Beauties"* ◆ *ōban* ◆ published by Hagiwara ◆ Two or three other prints from the same series are known. The basic idea seems to be that each of the women shown affects the manner of some well-known Kabuki actor—in this case, Baikō. The bold masses of the kimono and obi and the predominant use of black give this woman a strange, almost sinister air. The object in the background is a hibachi, a container filled with powdery ash in which burning charcoal is placed for heating.

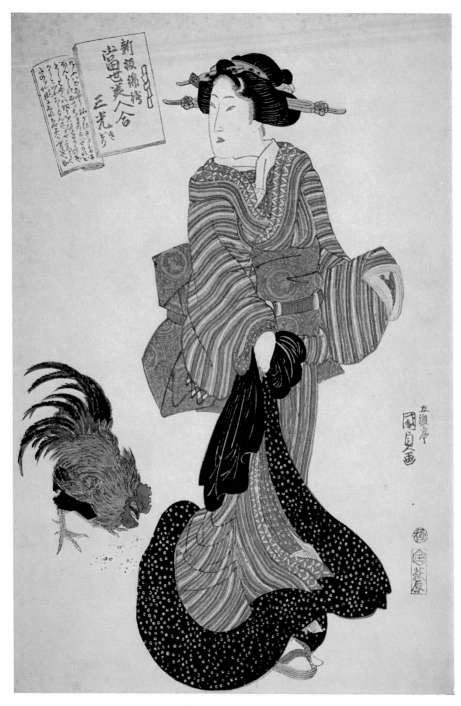

3. *Kunisada* ◆ *The Would-be Sankō, from "New Nishiki-e Contemporary Beauties"* ◆ *ōban* ◆ published by Hagiwara ◆ Another example from the same series as the preceding print. "Sankō" was a pseudonym of the actor Nakamura Matsue III, an Osaka player who came to Edo in 1813. The woman shown would seem to be an ordinary married woman from the merchant class. Note both the pose and the treatment of the kimono.

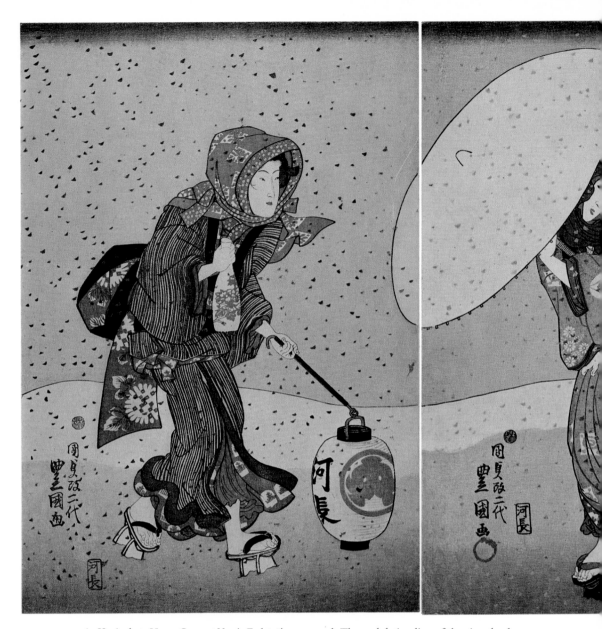

4-6. *Kunisada* ◆ *Heavy Snow at Year's End* ◆ *ōban* triptych ◆ published by Kawachō ◆ This work has considerable significance historically, since the signature clearly shows that it was published after Kunisada's succession to the title of Toyokuni II (strictly, Toyokuni III). Following this change of name, in the Kōka, Kaei, and Ansei eras, he produced little good work, but this triptych is a notable exception. The composition, including the sense of movement in the figures, is good. The undulating line of the river bank successfully binds the three parts together, and the three figures are well balanced against each other. In this version of the work (there are said to be four in all), the white pigment used for the falling snowflakes has become discolored in places; in other versions, the paper is left white without use of pigment. The other versions also show variations in the background—in one, for example, the background is said to be done in black.

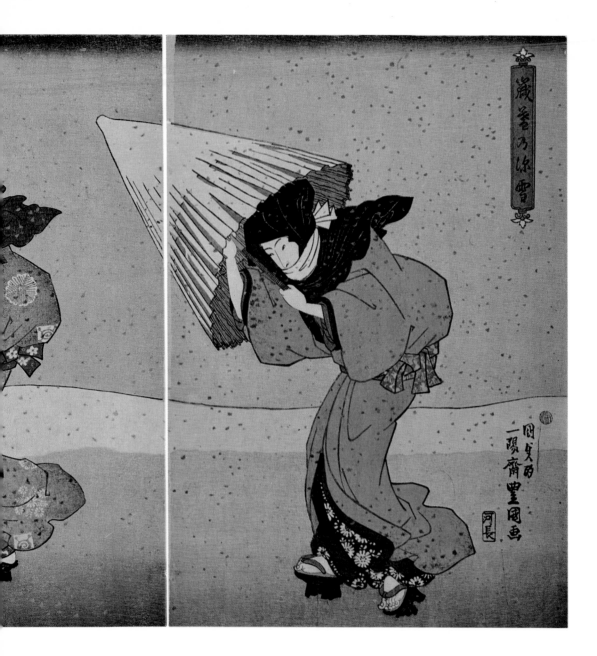

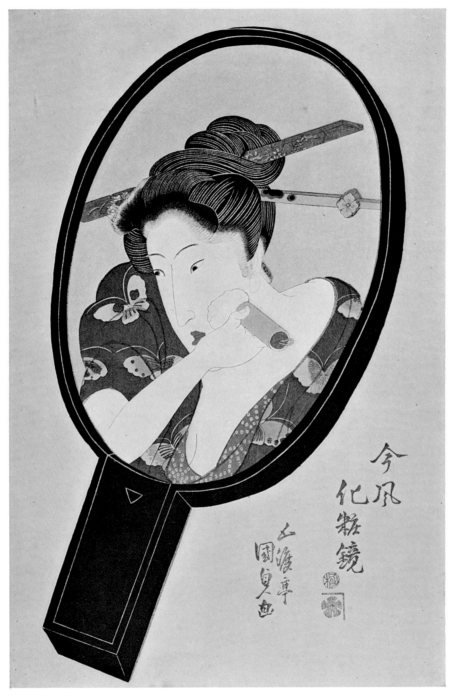

今風化粧鏡

7. *Kunisada* ◆ *Woman Using a Powder Puff, from "Fashionable Looking Glasses"* ◆ *ōban* ◆ published by Azumaya Daisuke ◆ Various other prints are known from the same series, including a "Woman Cleaning her Teeth," a "Woman Applying Lip Color," a "Woman Blackening her Teeth," a "Woman Plucking her Eyebrows," and so on, and the set may well have consisted originally of ten prints. Here, Kunisada portrays a woman of the merchant class with the pert, lively air traditionally associated with the typical Edoite.

18

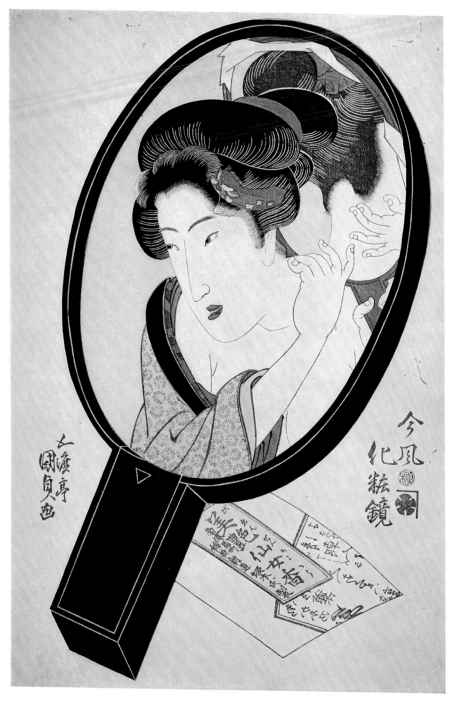

8. *Kunisada* ◆ *The Double Reflection, from "Fashionable Looking-Glasses"* ◆ *ōban* ◆ published by Azumaya Daisuke ◆ From the same series as the preceding print, the work shown here has a modern quality that links up with the art of the post-Restoration period. The packet below the mirror is inscribed "Bien Sennyokō," the name of a cosmetic that often occurs in ukiyo-e. The date of the work is approximately 1823.

9. *Kunisada* ◆ *The Mosquito Net, from "Starfrost Contemporary Manners"* ◆ *ōban* ◆ published by Iseya Rihei ◆ The meaning of the "Starfrost" of the series title is not clear, though the same characters with a different reading are used as an elegant word for "time." There were probably ten prints originally. The woman, probably the wife of a merchant, has lighted a strip of twisted paper and is trying to get rid of a mosquito that has flown into the net. The soft lines of the kimono emphasize attractively the line of the body. Both this and the following print have elegance with sensitivity of line and color.

10. *Kunisada* ◆ *The Footwarmer, from "Star rost Contemporary Manners"* ◆ *ōban* ◆ published by Iseya Rihei ◆ The woman shown here with her legs in the quiltcovered footwarmer is rather too stylish to be an ordinary housewife, and might well represent a teacher of some feminine accomplishment.

11. *Kunisada* ◆ *Fond of Fun, from "The Thirty-two Contemporary Marks"* ◆ *ōban* ◆ published by Nishimura Shinroku ◆ In the same way as Utamaro's "Ten Studies in Female Physiognomy" and "Warnings to Watchful Parents," this set depends for its interest on its skill in classifying particular types of women according to disposition and expression. In addition, however, it also captures clearly the characteristics of women in different stations in life—unmarried girls, married matrons, geisha, and so on. Variations in the thickness, flexibility, and strength of the line, as well as the use of color, succeed in suggesting not only the externals, but something of the inner state of mind as well.

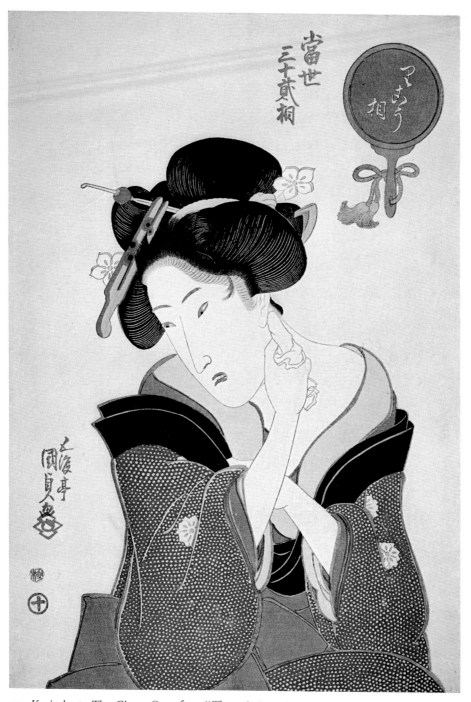

12. *Kunisada* ◆ *The Clever One, from "The Thirty-two Contemporary Marks"* ◆ *ōban* ◆ published by Nishinomiya Shinroku ◆ Another print from the same series of "character studies." As often happens with prints of this kind, it is rather difficult, for the modern eye at least, to find much connection between the title and the content. What is certain, however, is that this is a good example of the type of picture, showing a woman in some perfectly ordinary, unself-conscious pose, that was so popular towards the end of the Edo period.

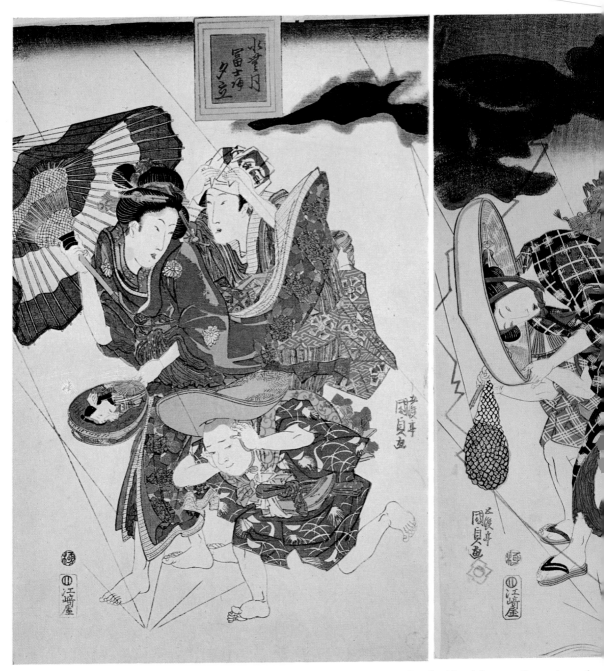

13-15. *Kunisada* ◆ *Shower on the Way Home, from "The Sixth-Month Fuji"* ◆ *ōban* triptych ◆ published by Ezakiya Kichibei ◆ In olden times, there was a small hill with a large tree on it at a certain temple in the Honjo district of Edo. On the first day of the sixth month one year, according to legend, there was a heavy fall of snow round about the tree. Everyone who went near it was afflicted with misfortune afterwards, so the local inhabitants built a small shrine there and, taking the hint from the unseasonable snow on the hill, dedicated it to the spirit of Mt. Fuji. Thereafter, a festival was held there every year on the first of the sixth month, and great crowds of worshipers would flock there. The figures shown here are on their way home from this

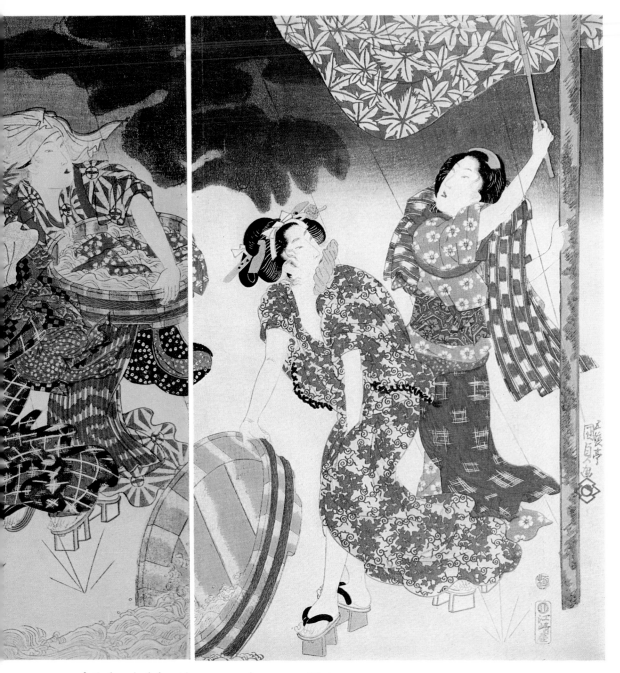

festival, mingled with some washerwomen. Their movements as they are taken unawares by a sudden shower and gust of wind are skillfully captured. There are too many colors and too much detail, but the work as a whole avoids garishness, and the grace characteristic of the art of the Bunka era is still in evidence, especially in the right-hand print.

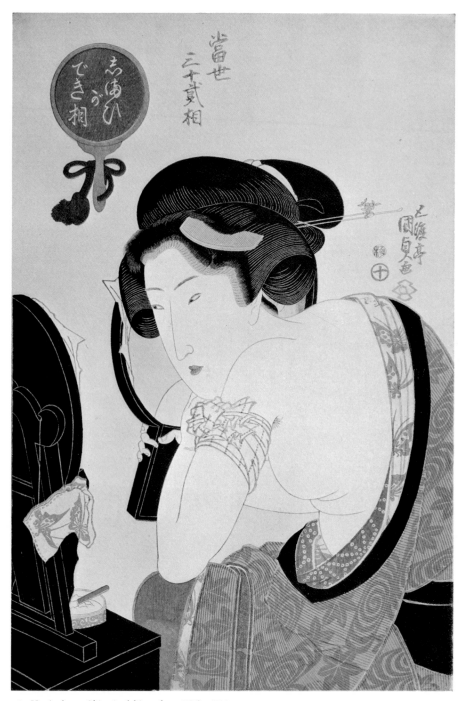

16. *Kunisada* ◆ *Shimaigedekiso, from "The Thirty-two Contemporary Marks"* ◆ *ōban* ◆ published by Nishinomiya Shinroku ◆ The woman has just been tattooed on her arm, and has bound it with a cloth, either to hide it or because it still hurts.

26

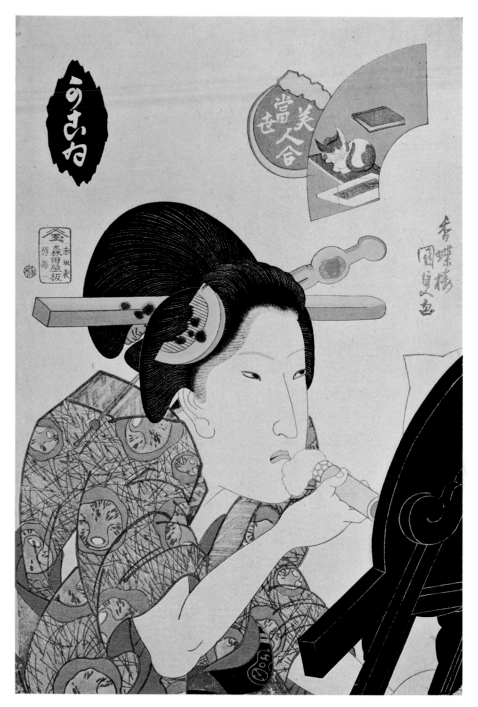

17. *Kunisada* ◆ *The Kept Woman, from "A Collection of Contemporary Beauties"* ◆ *ōban* ◆ published by Moritaya Hanzō ◆ In this work, both line and color are affected to some extent by the literalness and formalism that detract from much of Kunisada's later work. Nevertheless, it is still a strongly characteristic work, and is an admirable illustration of the decadent atmosphere that prevailed during the last years of the Edo Period.

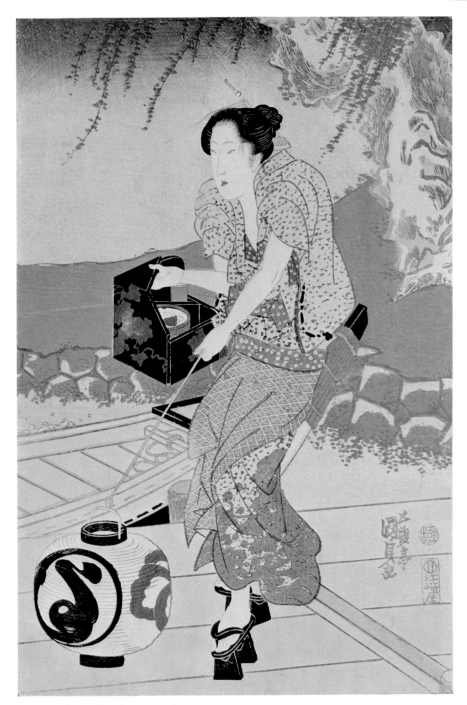

18. Panel from triptych on opposite page.

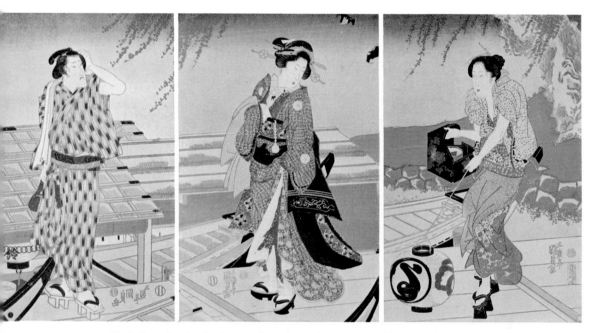

19-21. *Kunisada* ◆ *Leaving by Boat* ◆ *ōban* triptych ◆ published by Ezakiya Kichibei ◆ The man on the left is setting off in a boat, while the woman on the right, who would appear to be the proprietress of a riverside inn, has come to see him off. Judging from her dress, the woman in the center would seem to be a passing geisha. Of the three figures, that on the right is surely the best. The type of woman depicted is completely a product of the taste of Edo, and the style is no longer influenced by the culture of the Kyoto-Osaka area in any way.

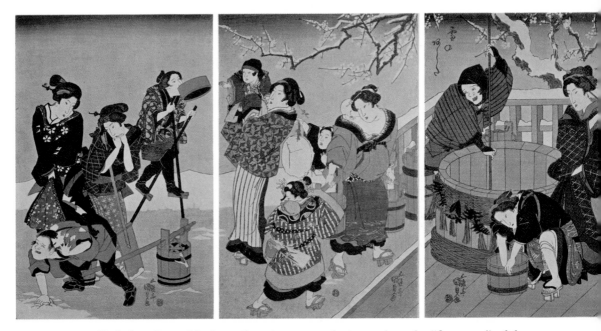

22-24. *Kunisada* ◆ *Snowy Morning* ◆ *ōban* trip-
tych ◆ published by Izumiya Ichibei ◆ An elab-
orate example of the *aizuri* technique, using as
many as five different blocks for the one basic
color, with touches of red here and there to give
variety to the whole. The decorations fastened
around the well and the battledore that the young
girl carrying the child holds in her hand suggest
that it is New Year's Day, and that housewives
are gathering to draw the "first water" of the
year. It is a homely scene that makes very effec-
tive use of the unpretentious beauty of the vary-
ing shades of blue. The gaze of all the figures is
directed towards the man who has fallen on the
left, which serves to tie the composition together.
The *aizuri* technique became very popular for a
while following the Tempō reforms, but this
particular work dates from before the reforms.

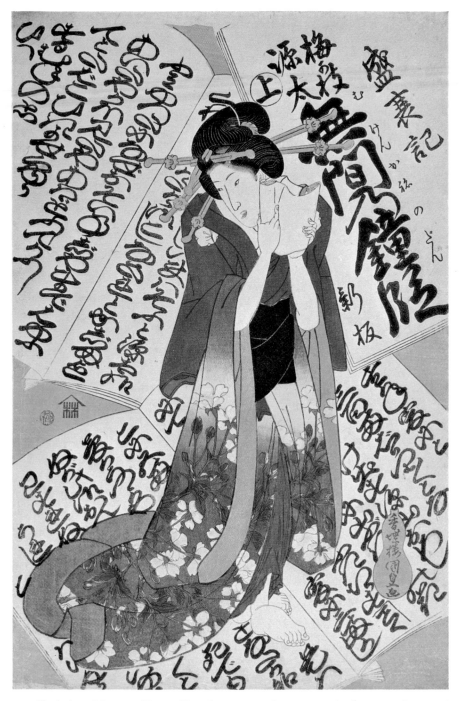

25. *Kunisada* ◆ *Mugen no Kane no Dan, from "Assorted Jōruri Libretti"* ◆ *ōban* ◆ published by Iseya Rihei ◆ An example from a novel series in which figures of beautiful women are set against a background of *jōruri* libretti. The *jōruri* is the ballad with samisen accompaniment that accompanies the puppet drama and many Kabuki plays, and the clean black and white pages of the libretti, with their very characteristic script, make a startlingly effective contrast with the bright colors of the kimono.

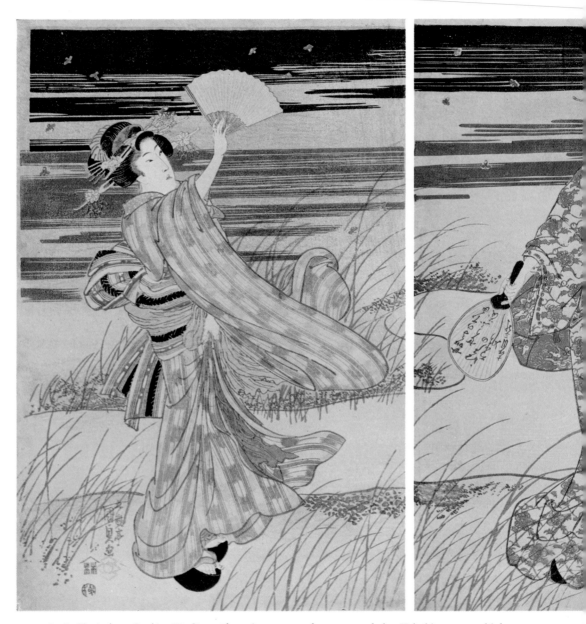

26-28. *Kunisada* ◆ *Catching Fireflies* ◆ *ōban* triptych ◆ published by Iseya Rihei ◆ It is a summer evening, and the three young women amusing themselves by trying—not very efficiently, it would seem—to catch fireflies are portrayed in postures deliberately reminiscent of the exaggerated poses struck by Kabuki actors at high points in their performance. Each of the three prints could be treated as an independent work, the only connection between them being the background; this kind of composition is very common among triptychs of this period.

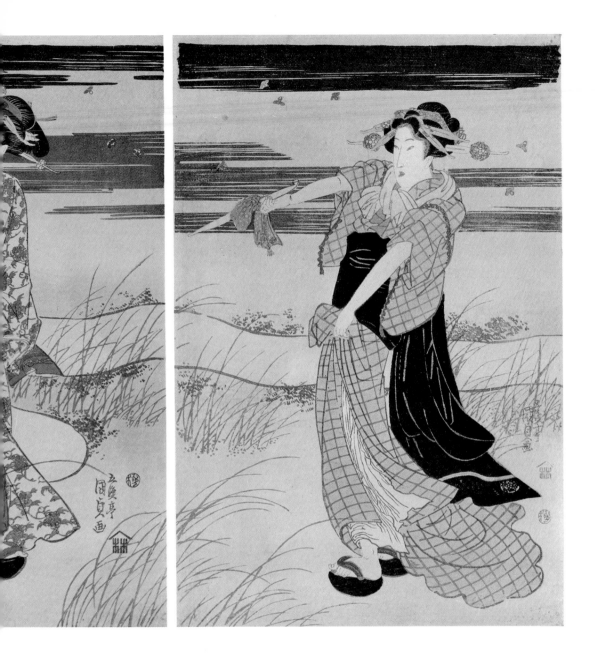

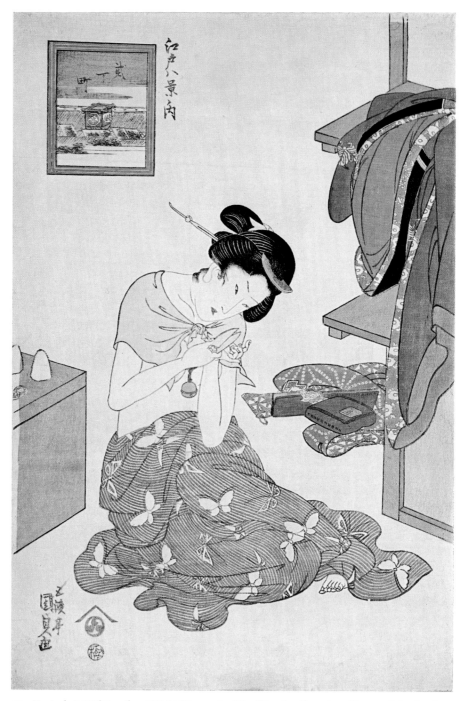

29. *Kunisada* ◆ *Nichōme, from "Eight Views of Edo"* ◆ *ōban* ◆ published by Nishimura Yohachi ◆ This set also dates from the early part of Kunisada's Gototei period, in which his preoccupation with a modest, refined type of beauty produced many excellent *bijin-ga.* The "Starfrost" set (see Pls. 9–10) is also in the same vein. It is not clear what kind of establishment is shown here—possibly a theater teahouse? The tobacco pouch and pipe case shown on the right would seem to be a man's.

34

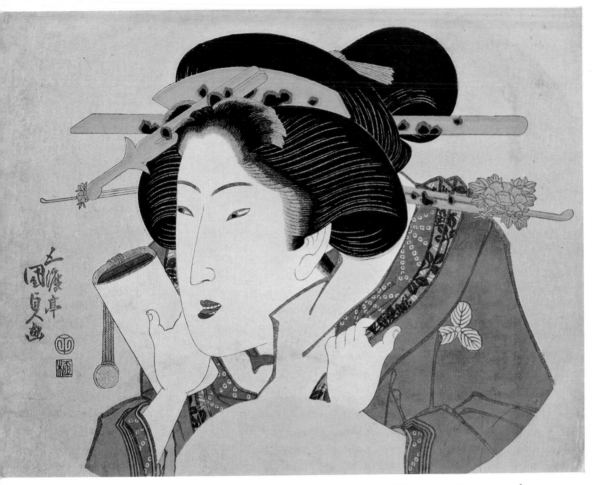

30. *Kunisada* ◆ *A Woman of Edo* ◆ *Decoration on paper for a
fan by Dansendo Ibaya* ◆ *Published by Senzaburo* ◆ This work
makes skillful use of the limited space available to portray
a typically sophisticated, stylishly dressed woman of Edo.

31. *Kunisada* ◆ *Oshichi, the Grocer's Daughter from "Popular Kabuki Plays"* ◆ *ōban* ◆ published by Kawaguchiya Uhei ◆ This print belongs to a series in which Kunisada shows well-known actors in various famous Kabuki roles. The actor shown playing the popular heroine Oshichi in this work is Iwai Hanshirō, who appeared in the play *Sono Mukashi Koi no Edozome*, presented at the Morita-za theater in the third month of 1809.

36

32. *Kunisada* ◆ *Rokusaburō the Carpenter, from "Popular Kabuki Plays"* ◆ *ōban* ◆ published by Kawaguchiya Uhei ◆ Another work from the same series as the preceding print. The play was *Mijikayo Ukina no Chirashigaki*, presented at the Nakamura-za in the seventh month of 1810, and the actor was Onoe Matsusuke II. This series is distinguished by its mica dust backgrounds.

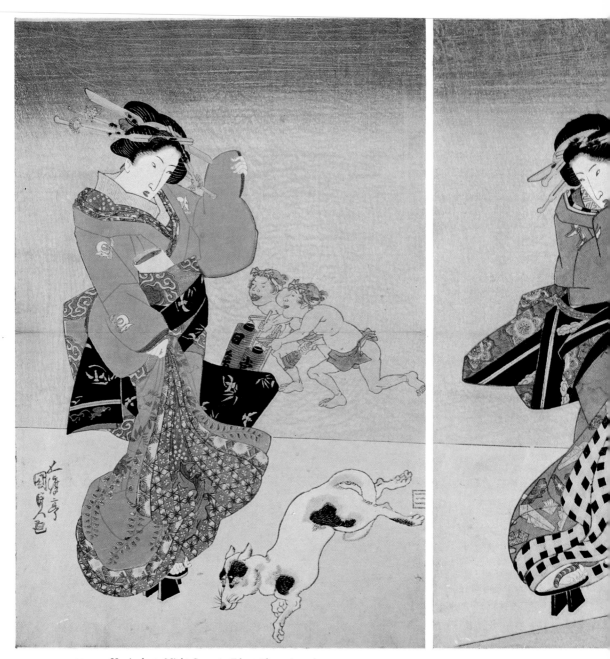

33-35. *Kunisada* ◆ *Night Scene in Edo* ◆ *ōban* triptych
◆ published by Shimizu ◆ The woman on the right
carries a lantern and what seems to be a samisen case,
which suggests that she and her companion are seeing
home the geisha on the left. The picture's chief claim
to novelty was undoubtedly the light of the lantern
streaming along the ground, and the silhouetted
figures in the background. In this work, one sees the
true "Kunisada-type" beauty coming into her own.

38

36. *Kuniyoshi* ◆ *Monhiko of Ōmiya* ◆ *ōban* ◆ published by Ezakiya Kichibei ◆ The lantern is extinguished and moonlight pours in through the barred window, forming a pattern of white and black stripes against the white wall and outlining sharply on the tatami the shadow of the geisha Monhiko as she slumps on the floor. There is a certain stiffness about the human figure, but it has a youthful charm, and while the effects of light and shadow are still immature, they hint at what was later one of Kuniyoshi's greatest preoccupations. Western influences are apparent in the design of the border to the inset and in the pattern of the woman's obi. The work hints at the course that Kuniyoshi's *bijin-ga* were to follow later.

40

Kunisada

KUNISADA was born in 1786 in the Honjo district of Edo. His father, Kadota Shōbei, who lived on shares he held in a wharf at "Itsutsume no Watashi" in Honjo, died the year following Kunisada's birth. "Itsutsume no Watashi," literally "Fifth Ferry," was apparently the popular name for a spot on the Tatekawa, a small river that flowed into the Sumida just a little downstream from Ryōgoku Bridge, one of the focal points of old Edo, and it appears as "Fifth Ferry" on contemporary maps. Kunisada's birthplace was most likely in the same district. Although he later moved to Kameido and finally to Yanagishima, he stayed in the same general area all his life, a true son of the low-lying areas bordering the Sumida River that were the home of the merchant culture of Edo—a son, moreover, of the area on the "far bank," which was noted for the dashing, volatile temperament of its inhabitants.

We are told that Kunisada's father died when he was only one year of age, but we know nothing of any brothers or sisters, or of his family as a whole. Records merely tell us—as they so often do about artists—that "he showed a fondness for painting from an early age." But the conventional remark may be true in his case, for his most impressionable years were lived in the Kansei era (1789–1801), the golden age of the ukiyo-e that produced the best work of Utamaro, among others. He was around nineteen, too, when Sharaku produced his mordantly realistic portraits of actors. The same era also saw the appearance of *Yakusha Butai no Sugata-e* ("Portraits of Actors on the Stage") and other works that first drew public attention to Toyokuni I, the man who was later to become Kunisada's teacher. It is said that around the Kyōwa era (1801–1804) or the beginning of the Bunka era (1804–1818) when Kunisada first became a pupil of Toyokuni, the latter was astonished at his skill in reproducing pictures that he was given to copy.

The earliest work of Kunisada's that can be traced today is the illustrations to the *Oisennukado Keshō no Wakamizu* by the well-known writer of popular novelettes Kyokutei Bakin. This work, however, was a privately commissioned work, and the earliest published works are the *gōkanbon* of 1808. Of these, both Shikitei

Samba's *Ōtsu Miyage Domori no Matahei Meiga no Sukedachi* and Santō Kyōzan's *Kagamiyama Homare no Adauchi* are claimed by their authors as Kunisada's first work. The former was an enormous success in its day, and it was this work that first made Kunisada's name. As Shikitei Samba himself says in his *Jottings:* "It was his first attempt at an illustrated novelette. It at once earned him considerable repute, and in the following years his popularity grew steadily until finally he emerged as a well-known ukiyo-e artist with a school of his own." The amount of work he did in the field of *gōkan* increased from this date on, and his first actor-pictures date from around the same time. His picture of the Kabuki actor Utaemon as Yojirō the monkey trainer in the play *Chikagoro Kawara no Tatehiki*, presented at the Nakamura-za theater in Edo in the fourth month of 1808, is said to be the earliest of them all. This was also a great success, and marked the beginning of a vogue for Kunisada actor-pictures.

Taking one character from the name of Toyokuni, his teacher, he called himself Ichiyūsai Kunisada. His many other artistic names include Gototei ("Fifth Ferry"), said to have been bestowed on him because he was born at the "Fifth Ferry."

It seems that Kunisada's first *bijin-ga*, more often than not women of the gay quarters of the Yoshiwara, were also put on sale around the same time (1808). An early example is the *Hokkoku Goshiki-no-sumi* ("Five Shades of Black in the Yoshiwara"). It was followed by a succession of first-rate works. The prints of the Bunka era include a considerable number that, though already departing from the style of Utamaro that had been so popular, still strove to achieve an essentially graceful type of beauty. Many of the works in this vein from Kunisada's early period are artistically excellent. In the skill with which he captures a posture adopted at one particular moment by a woman in the course of her daily activities and sets its essence down on paper one can sense the presence of young genius that astonished Toyokuni when he first discovered it in his new pupil.

The ukiyo-e of course, had long specialized in scenes showing how people (or certain types of people) lived and what they were, but in Kunisada one is struck at the outset by a greater realism in comparison with, say, Utamaro. The term "realism" must, of course, be understood within the context of the ukiyo-e; in very few *bijin-ga*, whoever the artist, does one find realism in the sense of the portrayal of truly individual faces, "warts and all." What is meant here is not so much that Kunisada suddenly showed an interest in the "warts," as that his women have a greater life of their own and that their activities are more particularized. In the previous age realism had been subordinated to the requirements of style and idealization, but with Kunisada, a suggestive atmosphere is replaced by a specific sensuality. In Utamaro's work, backgrounds had often been non-existent, flat yellow or mica-dust was used with the sole aim of helping to capture the quintessence of an idealized feminine beauty. In Kunisada's prints, even the

earliest of them, the clothing and the items of furniture arranged about the figure so simply and yet so skillfully serve not only to animate the scene but also to tell us something of the place, the atmosphere in which the women lived, and to create an extraordinarily vivid sense of feminine beauty in its real everyday setting.

Although these graceful women of the earlier ukiyo-e have their descendants among Kunisada's works, in the period from Bunka on into Bunsei he produced works such as *Hokkoku Goshiki-no-sumi* and *Tōsei Bijin Awase* ("Contemporary Beauties") in which a new type of woman emerges, at once more high-spirited and incisive, more sprightly and sophisticated. At the same time, Kunisada's prints of beautiful women often make skillful use of furniture or articles of everyday use such as smoking equipment to suggest the presence of the men who are almost never actually depicted in the ukiyo-e, so that in many cases it is necessary to take account of such background details in interpreting the expressions and postures of the women portrayed.

The beautiful women range from the daughters of merchants to married women, prostitutes and geisha, but as we have already seen, the women of pleasure are taken less and less from the licensed gay quarters of the Yoshiwara and more and more from the geisha houses and unlicensed brothels of the Honjō and Fukagawa districts that Kunisada knew so well. With this shift the dashing, stylish, sophisticated attitude on which these districts prided themselves gradually became the fashion of the new age, whose sensibility and tastes were faithfully reflected in the art of Kunisada. By the Bunsei era, his pictures of beautiful women, while retaining their flexibility and resilience of line, were showing marked differences from those of the Temmei and Kansei eras. Nor was it only the figures themselves; for the colors too become gradually stronger, with clear-cut contrasts that seem to symbolize the more vigorous, sophisticated nature of the women portrayed.

Kunisada produced a great deal of first-rate work in this period, including the "Fashionable Looking Glasses," the *Ukiyo Meisho Zue*, the "Thirty-two Contemporary Marks" and many others too numerous to mention. However, towards the end of the Bunsei era, one notes a prevalence of the type of pose—characteristic, one might say, of the *bijin-ga* as a whole during its last years—that has been described in various disparaging terms such as "bull-necked" or "hunch-backed." The hard, straight lines used in the treatment of the clothing had been noticeable here and there in the mid-Bunsei era or earlier, but it was not until the Tempō era that the special pose with bent back and knees became the order of the day.

Some of Kunisada's best work was done in his younger days, from the Bunka on into the Bunsei eras, when he produced large numbers of pictures of beauties and actors, and illustrations for works of popular literature. There is no space here to deal with the actor-pictures and illustrations in detail, but mention should at least be made of the type of *gōkan* known as *shōhon-jitate*, which was devised by

Ryūtei Tanehiko (1783–1842), and traded on the popularity of the kabuki, then at its height. A kind of novelized version of the kabuki, with scenes from the green room, the stage, and the lives of the actors themselves and including facial likenesses of popular actors of the day, it provided the ideal type of work for Kunisada. The illustrations to a work by Tanehiko entitled *Nise-murasaki Inaka Genji,* for example, are an excellent example of collaboration between author and illustrator. The pictures are full of detail and inventiveness and proved enormously popular. The book sold in huge numbers, and Kunisada's fame spread throughout the land.

As we have already seen, the enormous vogue enjoyed by the *gōkan* and other popular works had the effect of expanding their readership greatly within a short time, especially among the general public. This is a very significant fact, since it seems likely that the *nishiki-e* and especially the actor-pictures used the same routes in order to reach a public far wider than anything known during the Temmei and Kansei eras. Unfortunately, to cater to a wide public almost always implies a corresponding trend toward simplification and vulgarization, and mass production and over-production on the part of the artists brought an inevitable decline in quality.

Around the beginning of the Tempō era, Kunisada studied with Hanabusa Ikke, a pupil of Itcho. A marked change overtook his work in this era, and the beautiful women in his prints were transformed into the stumpy, hunched-up figures already familiar from the Bunsei era in the prints of the Utagawa school. It has been suggested that this type of womanhood—so ungraceful to the modern eye— was the ultimate result of the type of life that the women of the day lived. The unhealthy posture was forced on them little by little from the time of their childhood by their constrictive clothing and a life spent sitting hunched up on tatami and cushions. Even the great entrances of the merchant houses were closed at nightfall, leaving only a door so tiny that even a short woman, in passing through, had to hunch up her neck and shoulders. The foreshortened trunk, the thick, short neck, the knock-knees shown by Toyokuni and those who came after him were closely associated with the practical details of life in Edo at the time, and would in no sense have seemed unnatural to their contemporaries.

More "unnatural," in fact, were the idealized, impossibly graceful women of, say, Utamaro's prints. It is clear from the work of Toyokuni, Kunisada, Kuni-yoshi, Eisen, and their contemporaries that the realities of the women of the day— the poor physique, the stoop, the disproportionately short legs—were actually a stimulus that spurred them on into developing the peculiar sense of beauty summed up in their idea of *iki*—a beauty that depended largely on the line and color of the clothing and the details of the toilet. The *iki* that these artists expressed was different from that of the Temmei and Kansei eras; it was an *iki* peculiar to the late Edo period, and persisted on into the Meiji era after the opening of the

country to the outside world. The idea of smartness and the sense of style that are portrayed in these *nishiki-e* helped in turn to set the fashions of the women of the day. The treatment of the clothing, with its straight lines and its hard, angular feeling is to be found in the late work of Toyokuni I, and it is doubtful whether it was originated by Kunisada; both Kuniyoshi and Eisen also adopted the style at around the same time. However, no matter who may have started the fashion, it was probably no more than a stylization of something actually observable in the Japanese woman of the day.

With the passage of time from the Tempō on into the Kōka and Kaei eras (1844–1854) the signs of cultural decadence affecting society as a whole became more and more marked. The public taste ran to a more high-spirited type of woman than before, the kind of woman who openly flaunted her sophisticated, voluptuous charms. Following the Tempō era, as we have seen earlier, contact with foreign countries gradually increased, and the questions facing Japan both at home and abroad became increasingly pressing. The public became more and more preoccupied with novelty for its own sake, and the spiritual atmosphere of the age became increasingly uneasy. Technical standards in the production of ukiyo-e also went down (in fact, the stiffness of line of some of the *bijin-ga* has even been attributed by some to the need for mass production rather than the expression of a positive taste). Colors became more and more garish and the women became increasingly stereotyped.

The effects of this decadence are observable in Kunisada's work, yet it rarely lacks all artistic merit. In the year following his assumption of the title of Toyokuni II (strictly speaking, Toyokuni III), he conferred the title of Kunisada II on Kunimasa, one of his pupils. He moved from the Kameido district to a better location in Yanagishima, and lived there to the ripe old age of seventy-eight. He died in 1864, only four years before the Meiji Restoration and the beginning of the process of modernization that was to deal a final death-blow to the already ailing ukiyo-e.

ISABURŌ OKA

Kuniyoshi

THE popular image of Utagawa Kuniyoshi is of an eccentric among ukiyo-e artists. A fanatical cat-lover, careless of his personal appearance, dressed always in a plain crepe kimono with a simple obi, unaffected in his dealings with others, unable to keep money for long—in many ways his outlook was typical of the Edo artisan class. The unorthodoxy of his personal conduct was matched by the new style and sense of form apparent in his work, and by an artistic approach somewhat at variance with the then existing concept of the ukiyo-e.

To put it at its simplest, his view of things—the way he apprehended what he set out to show in his pictures—was different from that of other contemporary ukiyo-e artists in its essentially modern realism and in its constant search for novelty in the treatment of its subjects. Thus even in his generally rather under-rated warrior pictures, one not infrequently comes across figures that show a good knowledge of human anatomy and considerable courage in attempting to portray the human form from especially difficult angles. Particularly interesting is the way in which the elements of Western style and the use of chiaroscuro, with which he experimented enthusiastically at one stage in his career, are cleverly blended with the type of human figures and general style prevalent in the ukiyo-e after the rise of the Utagawa school. This technique created scenes that have a uniquely exotic air for the Japanese and are highly valued artistically today.

Kuniyoshi also produced characteristic work in the fields of the *bijin-ga* and actor-picture, those two staples of the ukiyo-e artist, as well as doing sketches and satirical pictures that are imbued with a typical Edo wit and sometimes even a rather naive spirit of rebellion. His pictures of animals and plants are well done; fish in particular display his keen observation, and have a great freshness. And the heroic quality of his warrior pictures—whatever the present-day estimate of the value of the genre may be—was undoubtedly the chief source of his appeal in his own time.

It was perhaps his upbringing and training that gave Kuniyoshi's art this great diversity. He was born on the first day of 1798 at Nihonbashi in Edo. According

to the *Ukiyo-e-shi Utagawa Retsuden* of 1894, by Iijima Kyoshin, his given name was Magosaburō and his childhood name Yoshisaburō. His father, Yanagiya Kichiemon, is said to have been a dyer by trade, and there are indications in Kuniyoshi's work that this theory is correct. A design resembling a dyer's sample book used as an inset to a series of *nishiki-e* entitled *Ryūkō On-somemono Chō* from the Tempō era (1830–1844) includes a name which seems to be a reference to his father. Similarly, the fact that he did illustration for a book entitled *A Rapid Guide to Dyeing*, published in 1853, suggests that he had some close acquaintance with the dyeing trade. It seems very likely that his upbringing and experience here were largely responsible for the effective use of patterns in the clothing worn by the beautiful women in the prints of his later years. His father's real surname (Yanagiya was his "trade name") is not known, but Kuniyoshi later took the name of Igusa.

All the information we have about Kuniyoshi's childhood is two unverifiable stories. One is that when he was seven or eight he liked to amuse himself by looking at picture-books by Kitao Shigemasa and Kitao Masayoshi, from which he picked up the ability to draw human figures. The other says that in 1808, when he was eleven, he did a picture of a well-known warrior holding a large sword that displayed excellent brushwork for one so young. Either way, it seems likely that the fondness for warrior pictures and the light, unforced depiction of scenes from everyday life that were his specialties in later years were first instilled into him during those early years.

At some stage in his youth, Kuniyoshi became a pupil of Utagawa Toyokuni I, though it is not clear exactly when and how this took place. An *Ukiyo-e Chronology* compiled by Urushiyama Tendō in 1919 and *Lives of the Ukiyo-e Artists* by Inoue Kazuo (1931) both give the year as 1811, but neither work cites its sources. One tradition says that Toyokuni I happened to see the warrior picture mentioned above and was much impressed, and that this led to his taking Kuniyoshi as his pupil. Even if this is so, it seems doubtful that Toyokuni concerned himself much about the fate of his new pupil. During the first half of the Bunka era whenever somebody from his own school published his first work in the form of illustrations for a book, it was Toyokuni's practice to provide a preface or picture in which, following the custom among kabuki actors, he introduced the younger man and commended his virtues to the public. However, although Kuninao, Kuniyasu and the other young hopefuls of the Utagawa school all received the benefit of such an introduction, nothing seems to have been done for Kuniyoshi. The *gōkan Gobuji Chūshingura* (1814), now believed to have been Kuniyoshi's first work, is an unpretentious work showing no sign of any particular attention paid to it by the young artist's teacher.

It may well be that there was some coolness between the two men. One is tempted to link this with a passage on Kuniyoshi in a collection of essays by a

certain Hirose Rokuzaemon that says, "He was of such a wild, unbridled disposition that even his relatives turned their backs on him," and to conclude that his master Toyokuni avoided him for the same reasons. Also, a passage in the *Ukiyo-e-shi Utagawa Retsuden* already quoted above says that Kuniyoshi was often short of tuition fees and had to eat at the house of his fellow-pupil and senior Kuninao, which may well mean that there was some unpleasantness over financial matters. Another theory, that at first he was a pupil not of Toyokuni but of Katsukawa Shuntei, also seems to hint at some instability in the early years of his artistic schooling.

As we have seen, the first book Kuniyoshi illustrated was probably *Gobuji Chūshingura*. His first polychrome print, so far as research can tell, is a single vertical *ōban* sheet showing the actor Nakamura Utaemon III in the play *Oriawase Tsuzure no Nishiki,* which was performed in 1816. However, it seems that he had published work of some kind even before these two works, since in an account of novelists and ukiyo-e artists published in 1813 his name appears in a lowly twenty-seventh place among the artists of the first grade. Whatever the exact details, however, it is safe to say that his artistic career began in the closing years of the Bunka era.

Following the two works just mentioned, Kuniyoshi produced illustrations for an average of two books every year, together with a few polychrome prints of actors. His style in this period owes a good deal to that of Kuninao. At the same time, however, he already seems to have felt a great admiration for Hokusai, the towering figure who had already had such a great influence on Kuninao. One can detect the signs of this influence in, for example, his early illustrations for the type of popular literature known as *yomihon*. This tendency of Kuniyoshi's to yearn for the style of other schools, and of Hokusai in particular, was to stay with him in later years.

Despite the ambition shown in the early works, he was soon to be visited by misfortune. From 1817 on, all orders from publishers for illustrations seem to have ceased. The cause may have lain in his tardiness in making a mark on the artistic scene compared with other members of the same school or in his failure to achieve a real individuality in the works that he had already published. However, more than any immaturity of his art as such, the reasons seem to have lain in social factors such as his failure to get the backing of his teacher, his failure to tie up with one particular author with whose works his illustrations might become associated, and his failure to get the support of a particular publisher.

Not a single book with illustrations by Kuniyoshi survives from the years 1818–1827. Only in the field of polychrome prints did he produce anything that might be called a success. This was two *ōban* triptychs, one depicting the appearance of the ghost of the warrior Taira-no-Tomomori, the other entitled *Oyama Sekison Rōben no Taki no Zu*, both published by Azumaya Daisuke in, it is

said, the early part of the Bunsei era (1818–1830). Strangely enough, these two works that appeared almost simultaneously—one a warrior picture, the other a genre picture—pointed the way to what were to be Kuniyoshi's two chief specialties in later years.

The success of these two works may have gained him some standing with the publisher Azumaya, for probably in 1821 he also published a work by Kuniyoshi showing the actors Onoe Kikugorō III and Seki Sanjūrō in three-quarter length. Although rather stiff, the work is full of vigor. Even so, because his actor-pictures appeared at a time when both Toyokuni and Kunisada were still producing some of their best work, they seem to have created little stir, and today one comes across only a few works from this period, including two that seem to date from 1823 and 1824 respectively. He also did a few warrior pictures, but none of them seem to have achieved any great popularity.

Such a modest degree of success must have meant that Kuniyoshi was in continual financial straits. A frequently told anecdote that appears in the *Ukiyo-e Hyakka Den* and elsewhere tells how poverty forced Kuniyoshi to work as a hawker. He was walking by the Sumida River one day when he caught sight of his former fellow-pupil Kunisada being entertained by geisha on a boat beneath a bridge, and was so incensed by the sight that he returned home forthwith, and set to work to improve his own technique with the aim of outstripping Kunisada. Even allowing for the usual artistic license of such anecdotes, it seems likely that this period for Kuniyoshi was one of groping insecurity and mental stress.

Two happy chances were to rescue him from this crisis, and set him on the road to becoming the leading light of the Utagawa school. One was that he became acquainted with the *kyōka* poet Umeya Kakuju, the other was the great success of his color prints inspired by the Chinese classic *Suikoden*. By trade, Umeya Kakuju, whose real name was Enshūya Sakichi, was a forage merchant in the service of Lord Owari, but his hobby was writing *kyōka,* the 31-syllable humorous verse popular at the time. He was six years younger than Kuniyoshi, but understood the older man's art and provided him with a great deal of inspiration, maintaining the friendship all his life. He also seems to have given Kuniyoshi various kinds of practical patronage.

The project that finally marked Kuniyoshi's arrival as an artist was the series of color prints depicting the heroes of the *Suikoden*. The literary work on which they were directly based was written by Kyokutei Bakin, the leading novelist of the day, who had started making adaptations of Chinese novels as a change from the kabuki-inspired works common until that time. Particularly famous among such works was his *Keisei Suikoden* (first edition 1825) in which all the heroes of the *Suikoden* reappeared as women. The work was an immense success, and touched off something of a *Suikoden* boom. Kuniyoshi's work took advantage of this vogue. Nothing is known about who first had the idea of producing a color

print series on the subject or how the task came to be given to the virtually unknown Kuniyoshi, but it may well be another case of his indebtedness to Kakuju.

The first series of prints on this subject so well suited to Kuniyoshi, *Tsūzoku Suikoden Gōketsu Hyakuhachinin no Hitori*, consisted of five sheets. Their great success with the public led to the publication of further works in the same series, and Kuniyoshi rapidly rose to prominence as an artist excelling at warrior pictures. The date is believed to have been around 1827.

Once his artistic reputation was secured by the success of the *Suikoden* series Kuniyoshi enjoyed a sudden increase in commissions, and the period that followed was one of great activity. In 1828 he began doing illustrations again, and the scope of his *nishiki-e* work expanded to include pictures of beautiful women and landscapes as well as the warrior pictures for which he was now famous. The transition from the series of prints entitled *Fūzoku Onna Suikoden* to the series *Sankai Meisan Zukushi*, prints done in varying shades of blue *(aizuri)* in which beautiful women are set against landscape backgrounds, shows his admirable artistic development in this period.

The Tempō era was a period of innovation for Kuniyoshi's art. At the very beginning of the era he published a series of Western-style landscapes that contain some of his very best work. The ten prints in the series *Tōto Meisho* ("Famous Spots in Edo") skillfully assimilate the Western chiaroscuro technique into Kuniyoshi's individual sense of form. The five works whose titles begin with *"Tōto"* and the other landscapes in the same vein are novel in the effective use they make of the *itabokashi* technique (color gradations achieved through varying the thickness of the color on the block), and they hold a noteworthy place in the history of the Japanese landscape print.

It is not clear where Kuniyoshi acquired his knowledge of Western art. The *Ukiyo-e-shi Utagawa Retsuden* relates that he owned several hundred Western-style pictures including some Western newspapers with illustrations, and that he himself declared Western art to be the only true art, which he intended to imitate. However, the names of the works in his possession are not listed. One might hazard a guess that the collection included some etchings by Aōdō Denzen (1747–1822), noted for his paintings and etchings in the Western style, since—to cite only one of several examples—one work in a series by Kuniyoshi on the theme of the "Twenty-Four Paragons of Filial Piety" is obviously a copy of one section of a work by Denzen, *Masusaki Inari Sumidagawa Chōbō*.

Alongside his Western-style prints, Kuniyoshi also produced such typically Japanese-style landscapes as the prints showing scenes at the third to sixth inns from the "Fifty-Three Stations on the Tōkaidō Highway" and *Kōsō Goichidai Ryakuzu*. The latter, based on the life of Saint Nichiren, the thirteenth-century Buddhist leader, shows a strong influence from a picture book by Kawamura Bumpō, an artist of the Kishi school, entitled *Bumpō Sansui Ikō*, published in 1824.

From this time on, the scope of Kuniyoshi's artistic activity widened steadily. In the field of *bijin-ga*, he had already made daring use of moonlight and shadows in works such as "*Monhiko of Ōmiya*" a little earlier, at the end of the Bunsei era; to these he now added such spirited *bijin-ga* as *Tōryū Onna Shorei Shitsukekata* and *Tōsei Edo-ganoko*, which have the cheerfulness characteristic of all his work and a great sense of tension and vitality. In the field of actor-pictures, it was during this period that he produced the *Chūshingura* prints, in which the backgrounds are more important than the figures. From the same period, too, dates the *Hyakunin Isshu*, a stylish blend of the historical picture and the genre picture. The extent of his activities is indicated by a *senryū* (a seventeen-syllable comic or satirical verse, the frivolous equivalent of the haiku) which, translated literally, runs; "The reeds proliferate and hinder the ferry." The "reeds" here (in Japanese *yoshi*) is a pun on Kuniyoshi's own name, while the "Ferry" is an obvious reference to the pseudonym of his rival, Kunisada.

Other notable products of this period are his pictures of various flora and fauna, especially his pictures of fish, and his caricatures. His vivid, intensely alive pictures of fish have a unique character that sets them on a level with those of Hokusai and Hiroshige. His beloved cats also make frequent appearances from now on in prints that blend realism and humor in equal proportions.

This same touch of humor applied to the world of human beings gave rise to his *kyōga* (comic pictures). The pictures of actors dating from the Kaei period and entitled *Nitakaragura Kabe no Mudagaki* look as though they might have been scratched on a wall with a nail, and blend an odd sense of form with a humor that has an underlying streak of bitterness. In this, they stand apart from anything else in the ukiyo-e.

Add to these caricatures Kuniyoshi's in some ways naive sense of rebellion, and the result is his satirical pictures. Among the best of these works is the 1843 triptych *Minamoto Yorimitsu Yakata Tsuchigumo Yōkai o Nasu Zu*, which satirized the Tempō reforms. It is said that this work—which poked fun, under a thin disguise, at public figures such as the minister Mizuno Tadakuni, author of the reforms—landed Kuniyoshi in trouble with the shogunate, but that he managed, with great difficulty, to talk himself out of it.

In the face of the Tempō reforms, the ukiyo-e withered temporarily, but following Lord Mizuno's political demise there was a reaction in favor of even greater brilliance than before. Kuniyoshi's warrior pictures, which had escaped almost all official blame, were turned out in large quantities, with ever more elaborate engraving techniques; and since many of his former fellow-pupils dropped out of the running, leaving only Kunisada (now Toyokuni II) to rival him, he produced still larger numbers of *bijin-ga* and portraits of actors. Most of his best work in the field of *bijin-ga* is concentrated in this period from the Kōka era into the Kaei era. It includes works such as his "Night Scene on the Hatchō Embankment,"

and series such as his *aiban Edo Jiman Meibutsu Kurabe* ("The Glories of Edo"), in which he sets beautiful, typically Edo women with intelligent-looking, pleasant faces in lively contrast against backgrounds suggestive of the four seasons.

His warrior pictures from this period show him experimenting with new types of composition, using large subjects to bind the three parts of an *ōban* triptych into an organic relationship. The result is a number of works of striking original-ity, not to say eccentricity. The most successful of these include "Miyamoto Musashi Subduing the Whale," "The Pagoda at Mt. Yoshino" and "St. Mongaku Doing Penance Beneath the Nachi Falls." All of them suggest an almost violent element in Kuniyoshi's temperament. They call to mind the story that in 1852, at a gathering of painters and calligraphers, he drew a picture of a hero from the *Suikoden* on an enormous piece of paper, then took off his own outer kimono and used it to apply the color.

As time went by, the quest for the unusual occasionally led him into excesses. Examples of this are to be found in some of his warrior pictures and in his series "Twenty-Four Paragons of Filial Piety From China," with its ostentatious use of Western-style chiaroscuro. On the other hand, "The Old Hag of the Lone Cottage," a large framed painting on wood that was commissioned by the pro-prietor of a house in the Yoshiwara for presentation to the temple of Kannon at Asakusa in 1855, is a haunting work that makes extremely skillful use of just such techniques. It survived fires in the Ansei and Taishō eras, and was removed to a place of safety before the temple was destroyed during the war, so that today it hangs high up in the main hall of the new temple, a lasting tribute to the vigor of Kuniyoshi's art. A few years after this work, Kuniyoshi was stricken with para-lysis. The affliction seems to have been light enough to permit him to continue to do a certain amount of illustrating every year, though in some works it is obvious that his pupils have assisted him.

His outlook was progressive to the end. In 1860, when the port of Yokohama was opened to foreign vessels, he promptly produced works such as "Motomachi, Yokohama" that were prophetic of the popular *Yokohama-e* of later years showing foreigners and foreign-style buildings in the city. This was his last work, however, for he died on the fifth day of the third month of the following year, 1861, at his home in Genyadana. He was sixty-four. He was the founder of an artistic dynasty that extends via his pupil Tsukioka Yoshitoshi and Yoshitoshi's pupil Mizuno Toshikata to modern masters of Japanese-style painting such as Kaburagi Kiyokata and his pupil Itō Shunsui.

JŪZŌ SUZUKI

37. *Kuniyoshi* ♦ *The Wisteria at Kameido, from "The Glories of Edo"* ♦ *aiban* ♦ published by Ibaya Kyūbei ♦ In the Kōka era (1844-1848), the faces of Kuniyoshi's women became somewhat rounder, with more charm and more intelligence than before. The prints in this series all have insets showing a scene from a particular district in Edo in a picture of a woman containing some allusion to the thing for which the district was most celebrated. In this series, Kuniyoshi took considerable care over the postures and expressions of the figures—eyelashes, for example, are shown in minute detail. This print, one of the best in the set, dates from about 1845.

53

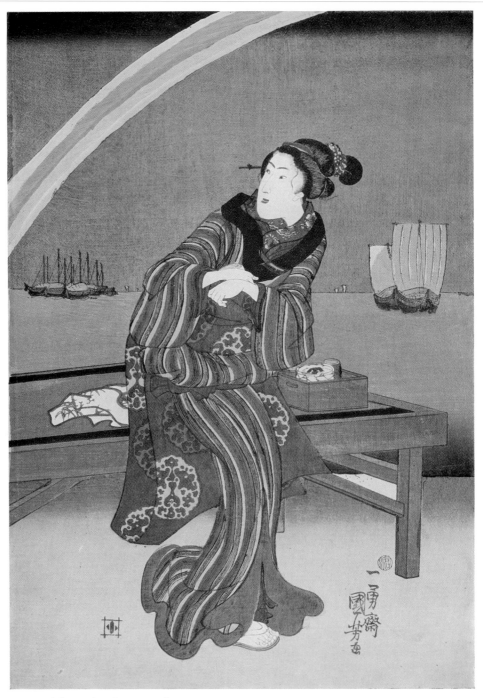

38. Panel from triptych on opposite page.

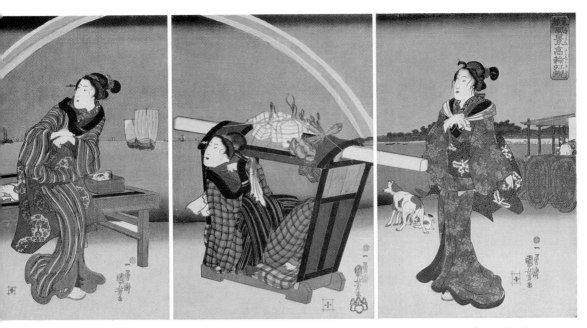

39-41. *Kuniyoshi* ◆ *Rainbow at Takanawa, from
"Scenes in Edo"* ◆ *ōban* triptych ◆ published by
Kogaya Katsugorō ◆ Three women on their way
home, probably from a picnic, are passing along
the shore at Takanawa (near the heart of modern
Tokyo). The rain has just stopped and they are
gazing at a great rainbow that has formed in the
sky. Their expressions are well captured, but it
is the splendor of the rainbow itself, the sug-
gestion of a rainstorm just passed over the sea,
and the skillful use of color that give the picture
its chief interest.

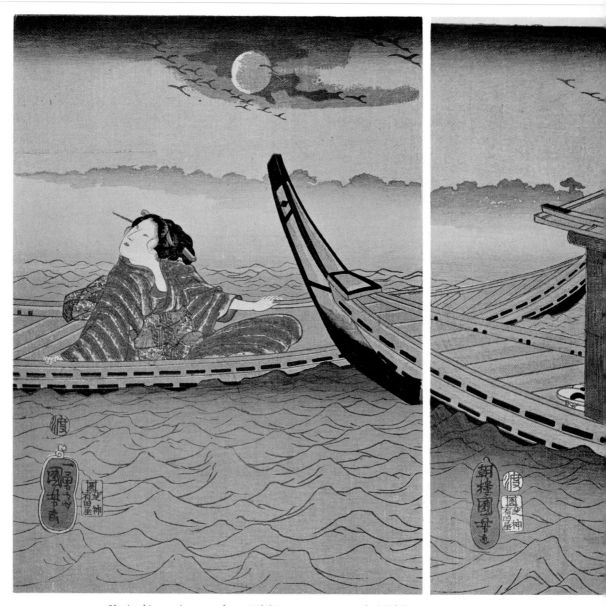

42-44. *Kuniyoshi* ◆ *Autumn, from "Shiki-no-kokoro Onna Asobi"* ◆ *aiban* triptych ◆ published by Aritaya Seiemon ◆ During the Kōka era, Kuniyoshi was fond of doing *bijin-ga* in the form of *aiban* triptychs. This work is perhaps the best, artistically, of a set of four representing the four seasons, and skillfully conveys a pervasive autumnal atmosphere. The lantern in the water was probably intended as a reflection of the lantern in the boat. The wild geese that are attracting the attention of the women and child as they fly across the moon are a typical symbol of autumn.

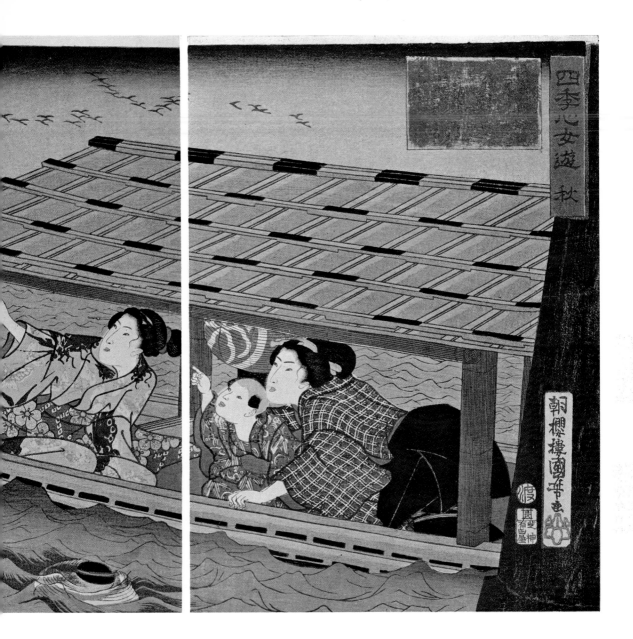

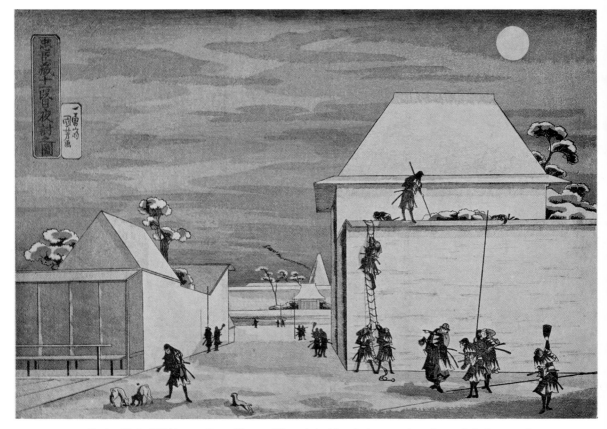

45. *Kuniyoshi* ◆ *Chūshingura Scene Eleven: The Assault by Night* ◆ *ōban* ◆ The most strikingly unusual of various works inspired by the celebrated tale of the "Forty-seven Loyal Retainers." The use of perspective is extremely effective, the composition-in-depth combining with a masterly use of chiaroscuro to produce a particularly effective "Western-style" picture. The use of the *ita-* *bokashi* technique at the edges of shadows and clouds helps greatly in achieving an effect of mass and texture. The shadows of the rope ladder and lance against the white wall effectively suggest pervasive moonlight, and the man throwing scraps to the dogs to keep them quiet is a striking touch of combined realism and poetry. The work dates from the early 1830's.

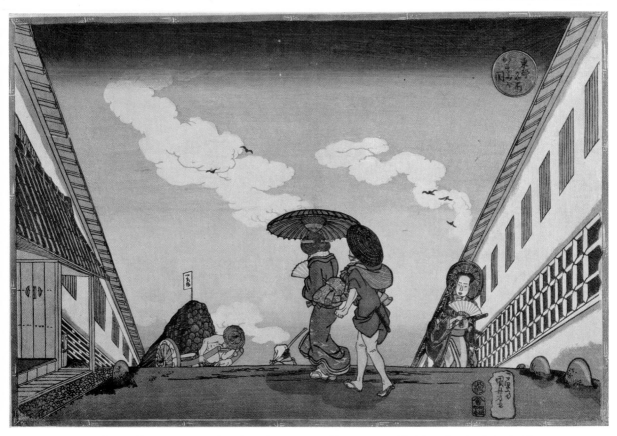

46. *Kuniyoshi* ✦ *Kasumigaseki, from "Famous Spots in Edo"* ✦ *ōban* ✦ published by Kagaya Kichiemon ✦ This work is part of a set of ten prints, the most famous of Kuniyoshi's landscape series. The most striking feature is, obviously, the composition; the skyline formed by the rise in the road is kept low in the picture, so that the walls of the *daimyō* mansions on either side loom with exaggerated height. The clouds in the blue sky and the shadows on the ground suggest the heat of a summer afternoon, the white lower half of the face of the samurai on the right is probably intended to indicate sunlight reflected from the fan he holds. The figure disappearing down the other side of the slope is a typical Kuniyoshi touch. The work dates from the early 1830's.

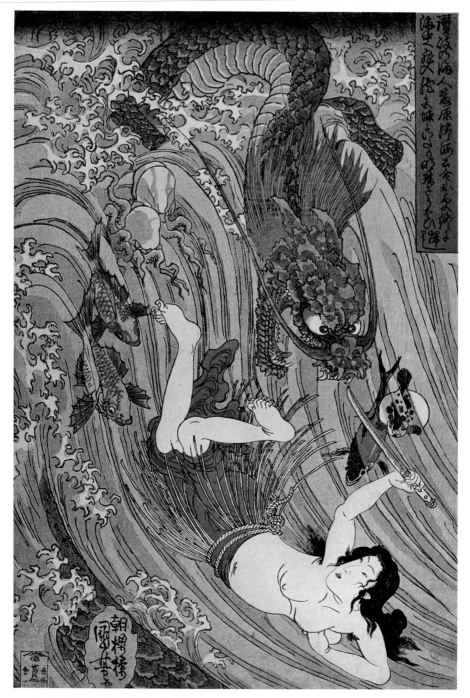

47. *Kuniyoshi* ◆ *Fetching the Lost Jewel* ◆ *ōban* ◆ published by Tsutaya Kichizō ◆ The legend of the diving woman of Shido Bay who risked her life to recover a jewel belonging to Fujiwara-no-Tankai that had been taken from him by the Dragon King has been dramatized in the Nō play *Ama*, and also in the *kōwaka* dance *Taisho-* *kukan*. It became generally popular in picture-book form, and made its appearance in the ukiyo-e at a comparatively early date. In this picture, Kuniyoshi concentrates on the diving woman and Dragon King. The bold, flowing composition and the novelty of the subject make this one of his most striking works.

60

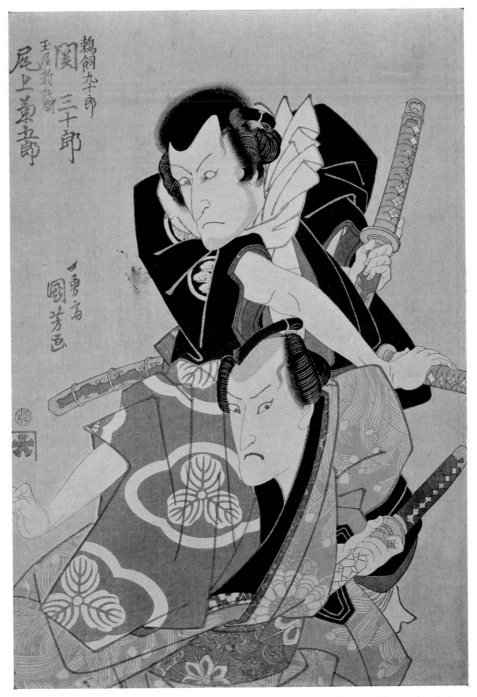

48. *Kuniyoshi* ◆ *Tamaya Shimbei and Ugai Kujūrō* ◆ *ōban* ◆ published by Azumaya Daisuke ◆ One of Kuniyoshi's early actor-pictures. The two actors playing the roles named in the title are, respectively, Onoe Kikugorō III and Seki Sanjūrō, who are believed to have performed them in a play put on at the Kawara-zaki-za theater in the seventh month of 1821. This kind of print, with two three-quarter length figures, is rare at this period of Kuniyoshi's work. The color scheme, with its predominant red and black, is pleasing, and the expression of Sanjūrō in particular is extremely realistic.

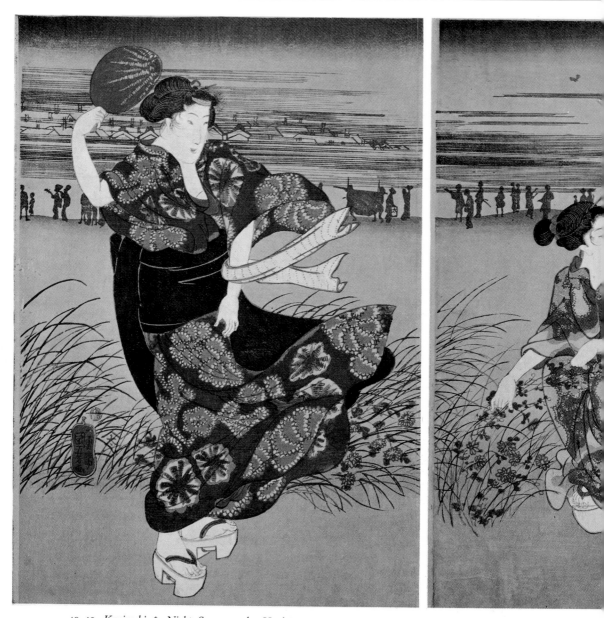

49-51. *Kuniyoshi* ✦ *Night Scene on the Hatchō Embankment* ✦ *ōban* triptych ✦ published by Ningyō-ya Takichi ✦ Kuniyoshi's *bijin-ga* from the Kōka era have the assured air of a personal style at last achieved. The three women here shown enjoying the cool of evening amidst the autumn grasses at the foot of the Hatchō embankment by the Sumida River in Edo all have a fresh, alert, typically Edo quality. The use of silhouette for the human figures and palanquin seen passing in procession along the top of the embankment is especially effective. A touch typical of Kuniyoshi is the yellow streak above the central figure, representing the passage of a firefly.

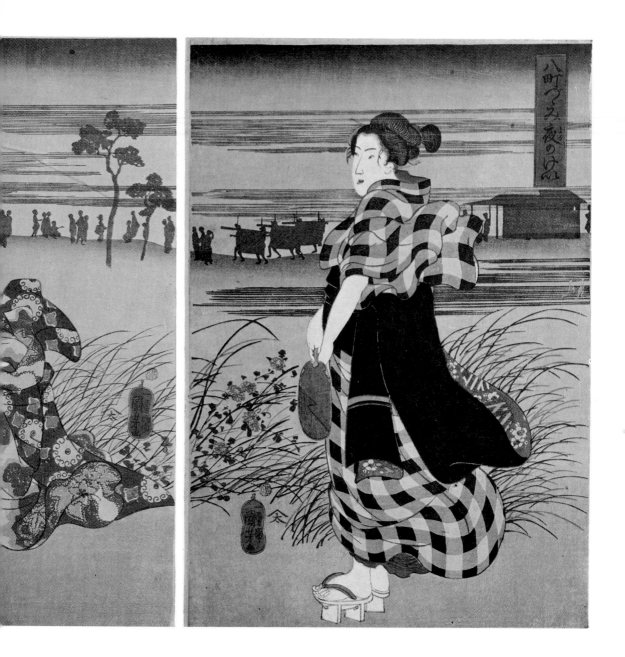

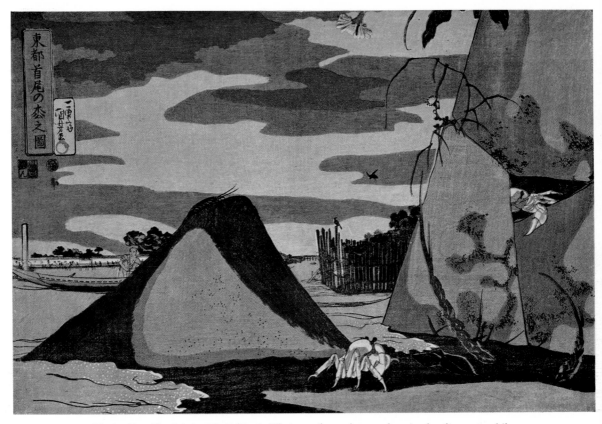

52. *Kuniyoshi* ◆ *The "Assignation" Pine in Edo* ◆ *ōban* ◆ published by Yamaguchiya Tōbei ◆ One of the most unusual and successful of the series of scenes of Edo published by Yamaguchiya. The pine tree, to which boats taking passengers to the Yoshiwara or on picnics were moored, is relegated to a place in the distance, while part of a stone embankment and the living creatures around it are shown in close-up in the foreground. The treatment of crabs and sea lice is extremely skillful, and yellow flowers set against a blue sky give the picture a touch of poetry.

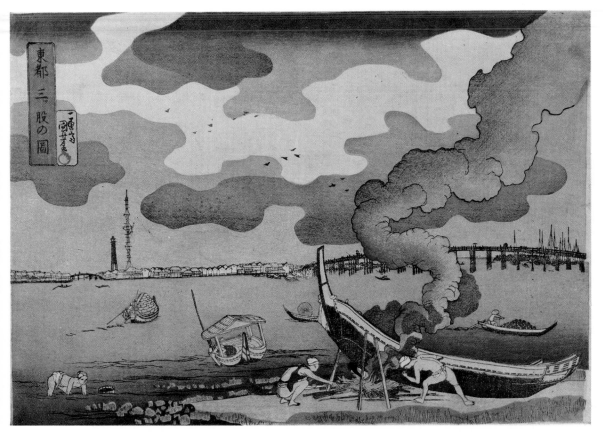

53. *Kuniyoshi* ◆ *Mitsumata in Edo* ◆ *ōban* ◆ published by Yamaguchiya Tōbei ◆ Another of the Edo scenes published by Yamaguchiya, but with an open, spacious feeling that contrasts strongly with the preceding print. The bridge in the background is Eitaibashi, with the island of Tsukudashima beyond it. The two men are charring the bottom of a boat to prevent the wood from rotting. The column of sepia smoke is very effective—it binds the composition together and goes well with the Western-style clouds peculiar to Kuniyoshi's work. The minuteness of the houses on the far bank emphasizes the width of the river and gives a feeling of great space to the scene. Notice the skillful treatment of the roofed boat rocking on the water.

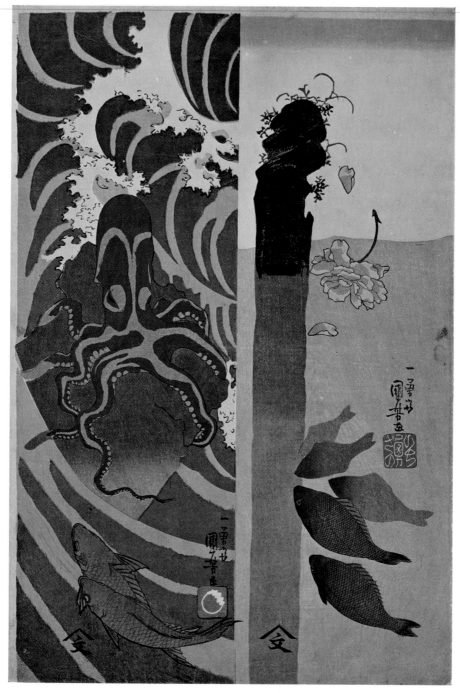

54. *Kuniyoshi* ◆ *Octopus and Roach* ◆ Twin *chū-tanzaku* (37.9 × 13.0 cm.) (15.1 × 5.2 inches) ◆ In this modern double print, the octopus clings tightly to a piece of rock in a turbulent blue sea, its rubbery, flexible texture suggested by a simple disposition of colors. The handling of the waves, part realistic, part stylized, is particularly interesting. On the right, the difference in brushwork and shading between the nearer and farther roach is very skillful. The irregular surface of the water suggests a slight rocking motion, and the fallen blossom not only holds the composition together but adds a poetic touch of color.

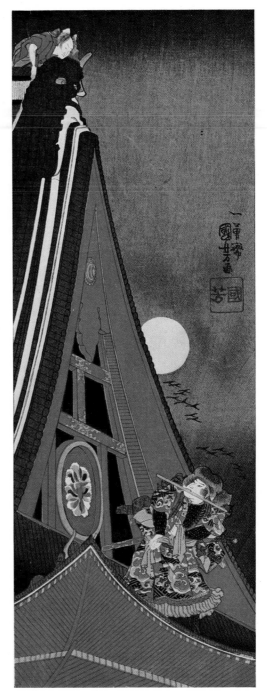

55. *Kuniyoshi* ◆ *Hōryūkaku* ◆ *chū-tanzaku* ◆
This work is inspired by a celebrated passage
in Kyokutei Bakin's novel *Satomi Hakkenden*
in which two heroes, Inuzuka Shino and
Inukai Gempachi, confront each other on the
roof of a building known as Hōryūkaku. The
work is small, yet the bizarre composition,
the feeling of tension created by the sharp
angle of the roof, and the touch of poetry in
the full moon with wild geese flying beneath
it give it considerable artistic interest. The
work dates from 1858, and is one of three
works pasted together on a single base, the
others being by Hiroshige and Hanabusa
Ittai (Toyokuni III).

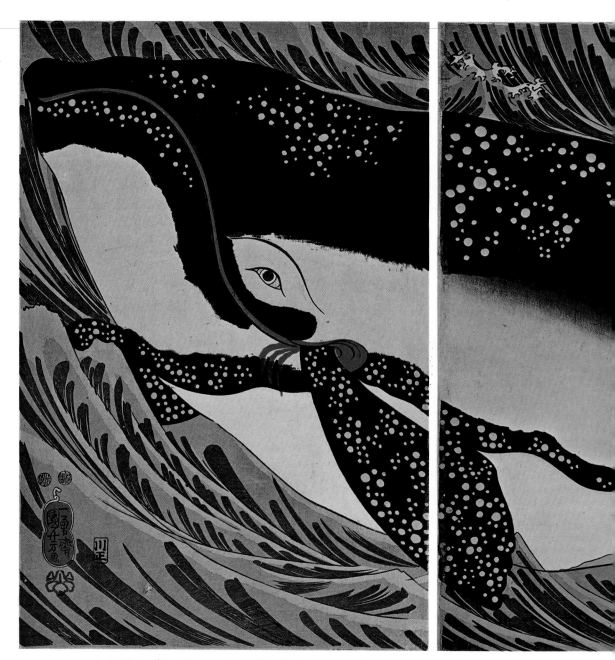

56-58. *Kuniyoshi* ◆ *Miyamoto Musashi Subduing the Whale* ◆ *ōban* triptych ◆ published by Kawaguchi Shōzō ◆ A work of extraordinary boldness and power that exploits to the full the possibilities of the *ōban* triptych form. Only Kuniyoshi, in his day, could have had the imagination thus to take a great wall of water as the basis for a composition. The dark blue shading on the waves, apparently so casually applied, is typical of Kuniyoshi. The simple colors of the greater part of the print—the blue water, the black of the whale, the white spots on its back and fins—are an effective foil to the brighter colors of the costume of the hero as he straddles the whale's back. Even Hokusai's "Great Wave off Kanagawa" is transcended here by Kuniyoshi's boldness.

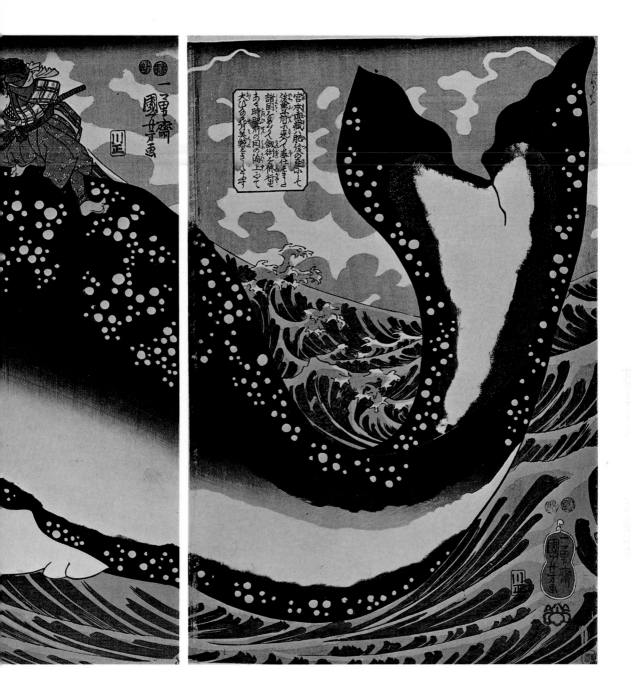

69

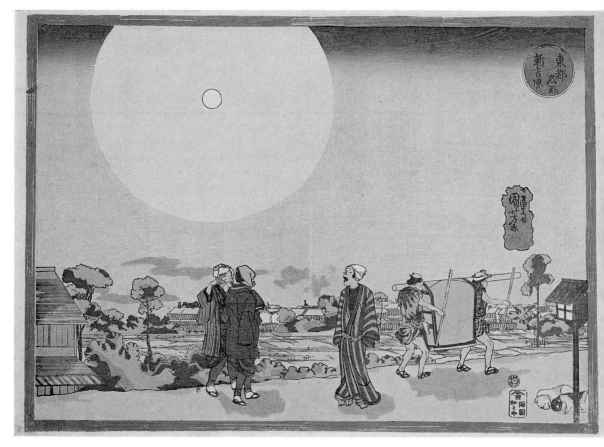

59. *Kuniyoshi* ◆ *Shin Yoshiwara, from "Famous Spots in Edo"* ◆ *ōban* ◆ published by Kagaya Kichiemon ◆ This series is one of the works that place Kuniyoshi securely on a level with Hokusai and Hiroshige as a landscape artist, and this particular print is one of the most celebrated in the whole set. In the light of a haloed moon, three men walking and a palanquin carried by two more men are passing along the embankment that led to the Shin ("New," since they were rebuilt after destruction by fire) Yoshiwara gay quarters, which formed an enclosure somewhat separate from the city proper. Touches such as the sleeping dogs and the lantern skillfully help to create the atmosphere, and the whole scene is wrapped in a gentle, nocturnal poetry. One seems almost to hear the man in the center singing a popular song as he strolls by. The Western-style chiaroscuro applied to the trees and roofs here does not seem out of place in an ukiyo-e work.

70

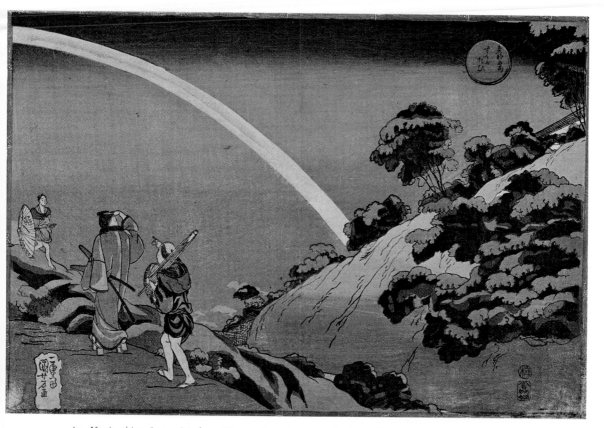

60. *Kuniyoshi* ◆ *Surugadai, from "Famous Spots in Edo"* ◆ *ōban* ◆ published by Kagaya Kichiemon ◆ Another print from the same series as the preceding. All the prints in the set are unusual in viewing the scene from a low angle and in skillfully assimilating Western-style chiaroscuro into the general ukiyo-e style. Here, a sudden shower has just ceased, and the dense greenery of the trees looks as though it is still dripping with rain. The three human figures—the samurai with his attendant in the foreground and the apprentice boy who comes twirling his umbrella to shake off the moisture—have noticed the rainbow that has appeared in the clearing sky. The whole print has a great freshness that gives it a high place within the series.

71

61. *Eisen* ◆ *The Evening Bell at Asakusa, from "Eight Scenes in the Yoshiwara"* ◆ *ōban* ◆ published by Tsutaya Jūzaburō ◆ This set of prints, one of the best-known of all Eisen's works, is another of the "eight views" series originally inspired by the Chinese "Eight Views of Hsiao-hsiang." The woman, the courtesan Komurasaki of the house of Tamaya, has been roused by the evening bell of the temple (shown in the inset) and, slipping out of bed, stands by the lantern gazing at her companion. This work dates from the Bunsei era.

72

62. *Eisen* ◆ *Suzaki Benten, from "Adakurabe Ukiyo Fūzoku"* ◆ *ōban* ◆ published by Ezakiya Kichibei ◆ With her body slumped against a pillar at such an angle that the inside of the garment thrown over her shoulders is visible, and with one foot resting on the other in order to maintain her balance, the woman in this print stands in a distorted posture such as one would find only in the later ukiyo-e—and probably only in Kunisada or Eisen. The work stops just short of the point where the pursuit of beauty in everyday things becomes virtuoso realism for its own sake. The abandoned pose is matched by the disorder by the dressing table.

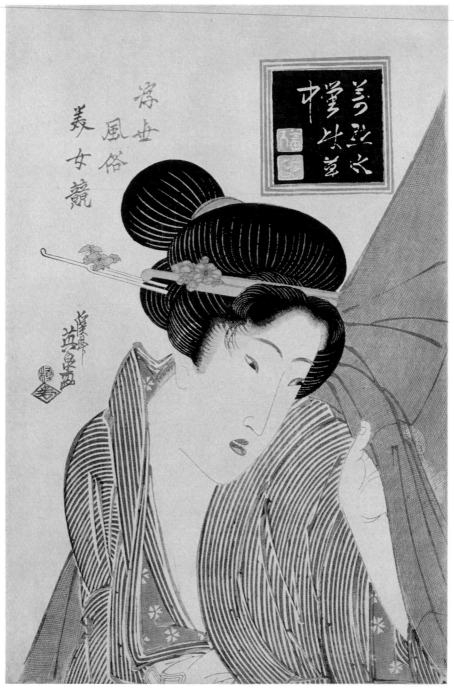

63. *Eisen* ✦ *Fireflies Among the Grasses, from "Ukiyo Fūzoku Mime Kurabe"* ✦ *ōban* ✦ published by Wakasaya Yoichi ✦ A work from what is generally considered Eisen's finest *ōkubi-e* (half-length portrait) series, done at a time when his creativity was at its peak. The individual prints are of a standard that bears comparison with Utamaro's great *ōkubi-e* series, but here the latter's idealized beauty is replaced by a more direct, actual, sensual type of appeal. The portrayal seems not to stop at surface beauty, but to capture the subtlest inflections of the feminine psychology as well. The care taken over the printing and engraving matches the artistic value of the pictures themselves.

74

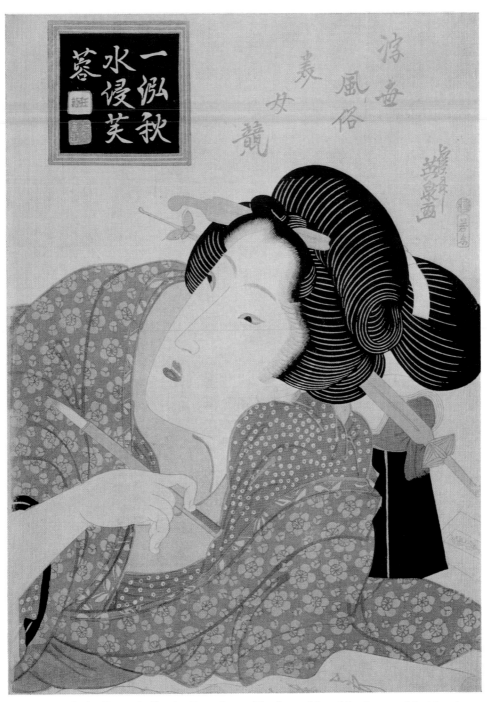

64. *Eisen* ❖ *Cool Waters Amidst the Fuyō, from "Ukiyo Fūzoku Mime Kurabe"* ❖ *ōban* ❖ published by Wakasaya Yoichi ❖ Another splendid example from the same series as the preceding print. This woman is writing a letter in bed, and the writing brush is still poised in her hand as she looks round.

The few articles of furniture used in this series are most effective in evoking atmosphere. Note the pale blue used for the whites of the eyes, the slightly impatient contraction of the eyebrows, and the suggestion of an iridescent sheen on the full lower lip.

75

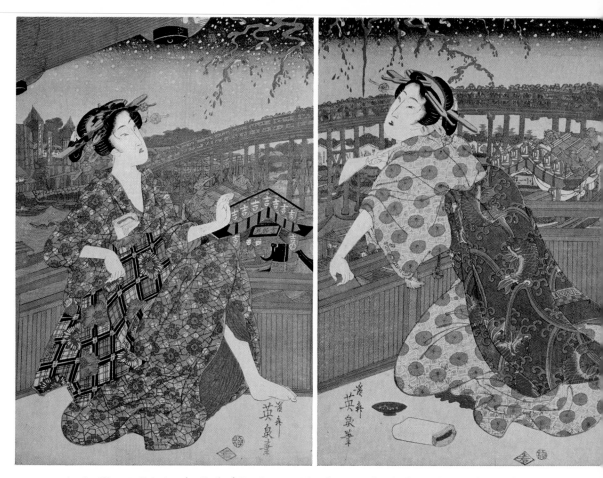

65-67. *Eisen* ◆ *Enjoying the Cool of Evening at Ryōgoku* ◆ *ōban* triptych ◆ published by Waka-saya Yoichi ◆ This work dates from the period when Eisen was still doing *bijin-ga* reminiscent of those of Eizan. The picture is overcrowded, but the care lavished on it is nonetheless remarkable.

The finesse with which another smaller bridge with a whole landscape in miniature is shown beyond the crowded Ryōgoku Bridge recalls some of the work of Hokusai. The treatment of the left hand of the woman on the left and her posture hint at the later mature Eisen style.

76

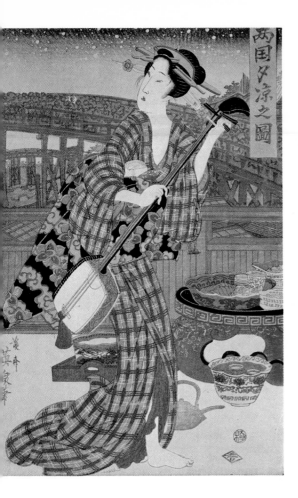

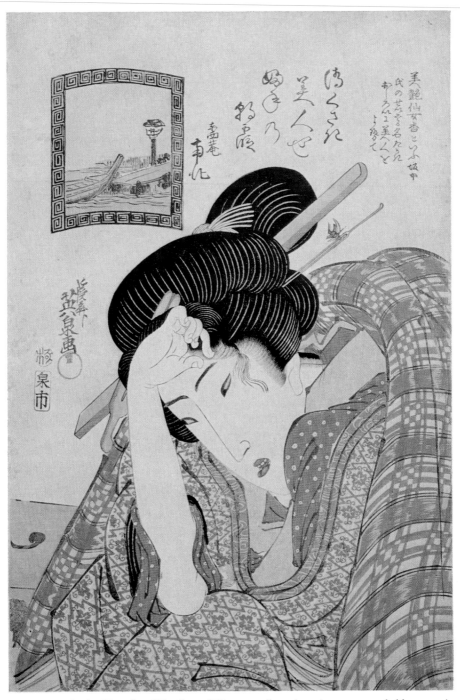

68. *Eisen* ◆ *Morning Haze, from "Bien Sennyokō"*
◆ *ōban* ◆ published by Izumiya Ichibei ◆ A
print from another series done in Eisen's prime.
Each print bears the inscription "Beautiful
women inspired by the celebrated cosmetic
Bien Sennyokō, manufactured by Mr. Saka-
moto," so the prints were probably commis-
sioned as a kind of advertisement. The woman
here is shown waking up in the morning, and
the disheveled hair and the hand pressed to her
forehead are particularly effective in suggesting
the first moments of wakefulness.

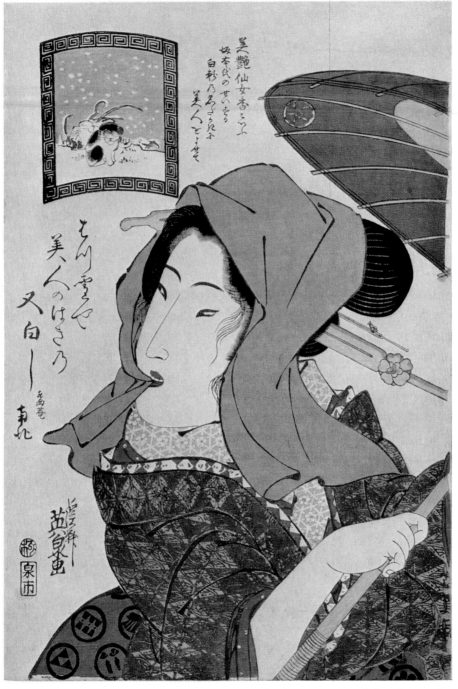

69. *Eisen* ❧ *Hatsuyuki, from "Bien Sennyokō"* ❧ *ōban* ❧ published by Izumiya Ichibei ❧ Another example from the same set as the preceding print. The attraction of the print lies especially in the coloring and in the suggestion of winter—in the scene in the inset, and in the woman's name, which means "first snow."

70. *Eisen* ❧ *Portrait of a Fashionable Beauty* ❧ *ōban* ❧ published by Itōya Yohei ❧ The woman is shown dressing, but despite the opportunities for color this offers, the color scheme as a whole is unusually sober for Eisen. Another unusual feature is the signature, which is in cursive script rather than the square script Eisen usually favored. The picture is saved from dullness by the bold white-on-blue pattern of the kimono the woman has put on and the huge butterflies on the black one folded over the screen to the right.

71. *Eisen ✦ Shinobu of Yase, from "Beauties of the Yoshiwara" ✦ ōban ✦* published by Tsutaya Kichizō ✦ This print, a product of Eisen's last years, is a good example of his more elaborate *aizuri* works. The courtesan Shinobu is shown plucking absentmindedly at the samisen as she runs through the ballad whose words lie on the floor before her. Only one color is used, a synthetic indigo pigment imported from abroad, but the rich variety of shades very effectively suggests the sumptuousness of a high-grade courtesan's garments.

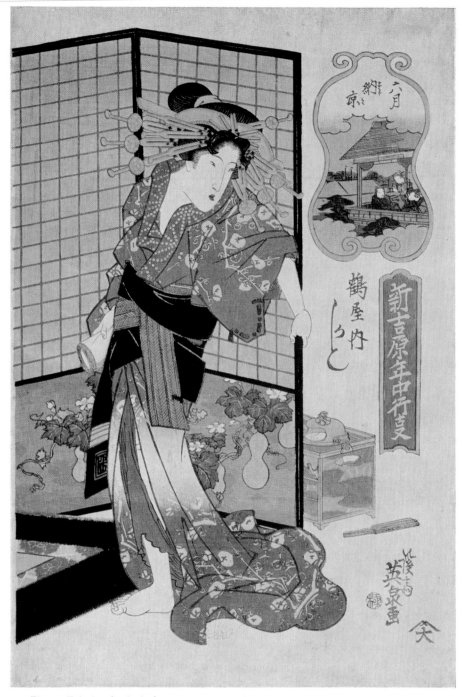

72. *Eisen* ❖ *Enjoying the Cool of a June Evening, from "Round the Year in the Yoshiwara"* ❖ *ōban* ❖ published by Jōshū-ya Kinzō ❖ The pictures showing yearly rituals in the Yoshiwara are relegated to insets, and the main part of each of the twelve prints in the set is devoted to courtesans in clothing appropriate to the particular season. The work dates from the Tempō era, and the face and pose show signs of becoming stereotyped.

82

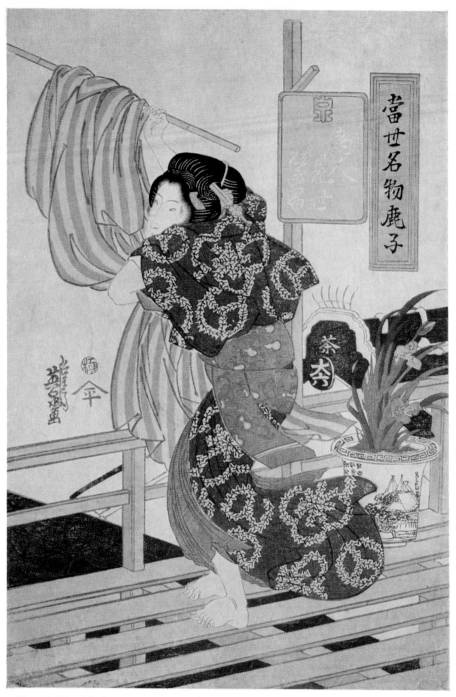

73. *Eisen* ◆ *The Merchant Stores Prosper, from "Tōsei Meibutsu Kanoko"* ◆ *ōban* ◆ published by Ōmiya Heihachi ◆ This series dates from somewhere around the beginning of Eisen's last period. The woman shown in this print is putting out washing to dry on the special platform often provided for the purpose on the roofs of merchant-class houses in Edo. There is realism in the skirt and obi fluttering in the wind, and in the toes tensed to maintain a foothold on the narrow planks. The work is a typical example of beauty found in a perfectly everyday scene.

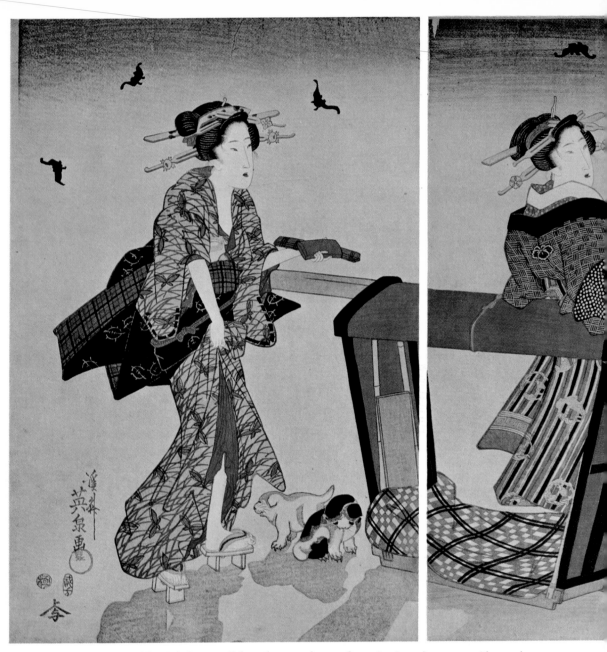

74-76. Eisen ◆ *The Night Lamp at Akiba* ◆ *ōban* ◆ triptych ◆ published by Uemura Yohei ◆ Bats flit in the sky, a lantern stands at the left with the inscription, "Akiba All-night Lantern," the moonlight casts shadows on the ground where two puppies play . . . Apart from these skillful evocations of atmosphere, there is little to distract the eye from the three figures: a geisha on the right, who comes humming to herself with a songbook in her hand, the woman who waits for her leaning against the palanquin, and the young attendant who stands behind. This work from the Bunsei era is one of the most successful of Eisen's triptychs.

84

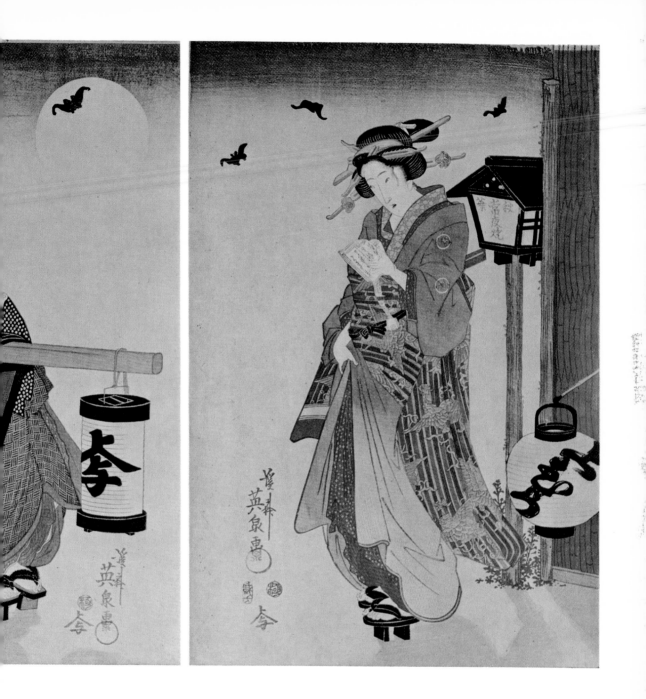

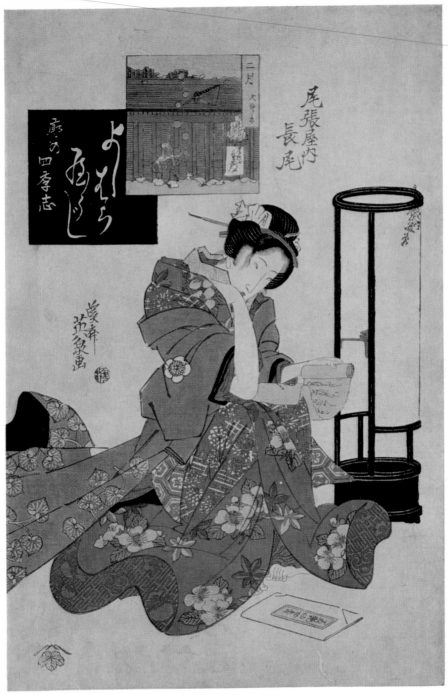

77. *Eisen* ◆ *Nagao of Owariya, from "Yoshi-wara Yōji Sato no Shikishi"* ◆ *ōban* ◆ published by Tsutaya Jūzaburō ◆ This is one of the earlier series from the period in the early 1830's when Eisen did so many prints inspired by the Yoshiwara gay quarters. The figure of the courtesan Nagao as she reads a letter, with her chin resting on her hand, has a quiet, unobtrusively sensual appeal that is typical of Eisen's best work. Particularly effective is the glimpse of her toes beneath the kimono.

86

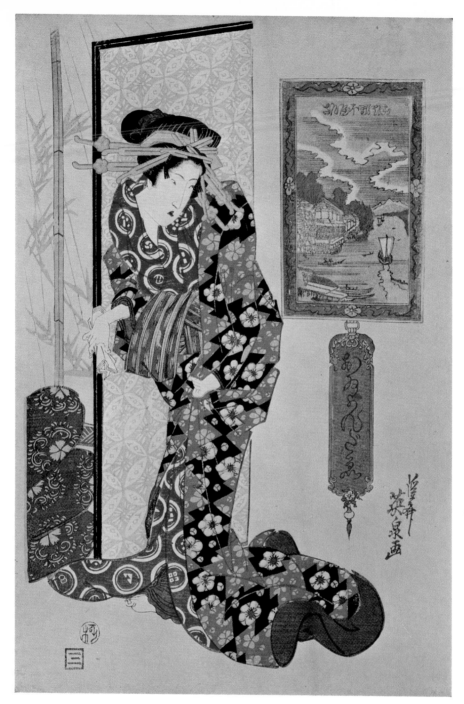

78. *Eisen* ◆ *Oiranda Picture: Sanya Canal* ◆ *ōban* ◆ published by Shimizu ◆ The title is a play on *oiran* (a high-grade courtesan) and *Oranda* (Holland). Another work has "Oiranda Mirror" in its title, and since the design of the inset is also similar, it is believed to belong to the same series. More interesting here than the figure of the courtesan is the influence of Western art apparent in the scene shown in the inset—the sense of perspective, for example, and the use of parallel lines for shading as is found in Dutch etchings. Even the writing in the inset deliberately imitates the "exotic" Western horizontal script.

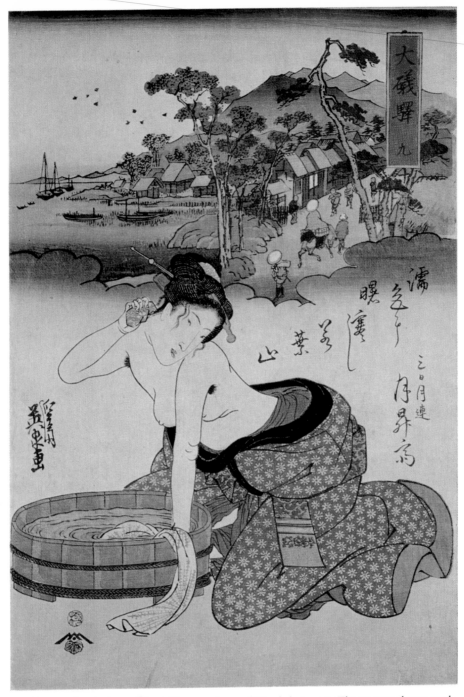

79. *Eisen* ◆ *The Station at Ōiso* ◆ *ōban* ◆ published by Tsutaya Kichizō ◆ This series of scenes at stations on the Tōkaidō Highway, each with a woman in the foreground and a landscape behind her, is one of the better works of Eisen's last years. The woman shown washing her neck in this print is a type already familiar from earlier ukiyo-e, but Eisen achieves his own special effect of actuality and sensual appeal.

Eisen

BOTH the writings and the art of Keisai Eisen suggest that he was a rather dissolute, eccentric, occasionally positively antisocial artist with a generally nihilistic air. In the *Mumei-ō Zuihitsu* ("Essays of a Nameless Old Man," also known as *Zoku Ukiyo-e Ruikō,* a much amended version of the *Ukiyo-e Ruikō,* the most basic source of knowledge on the lives of the ukiyo-e artists), he writes of his own life: "On one occasion, he disappeared while he was halfway through the preliminary picture for a print. The publisher, greatly incensed, searched for him and found him dead drunk in a brothel. Some time later, Eisen painted the scene for him and gave it to him. . . . One day, Eisen left home in clothes borrowed from his land-lord and did not return. After a while, the landlord found out where he had gone, and calling there found him insensible, having pawned the clothes and spent the money on drink. . . . He would go out in *haori* and *geta* as though he was going for a stroll in the neighborhood, only to arrive by boat the same night at Kisarazu in the province of Kazusa [on the other side of the bay from Edo]."

Yet this same man's pictures of beautiful women have a strangely sensual, enchantingly voluptuous beauty; although some critics condemn them as dec-adent, they undoubtedly opened up a world of experience hitherto unknown to the ukiyo-e. His landscapes, again, on which he lavished so much skill, include such celebrated works as the "Sixty-Nine Stations on the Kiso Highway," while in the landscape works employing Western-style chiaroscuro he originated a new style just as surely as Hokusai and Hiroshige had done before him. Credit must be given him, moreover, for the skill with which he took his stand midway between the Utagawa and Hokusai schools—the two great powers in the ukiyo-e world of late Edo times—and managed to compete with both of them. He also tried his hand at writing popular novelettes, and produced a number of historical essays. His activities, in short, display a variety as well as a quality that make him a very worthy object of study, whatever his personal shortcomings may have been.

Eisen was born in 1790 at Hoshi-ga-oka in Edo. His family name was Ikeda, and his given name Yoshinobu (he also used the name Shigeyoshi). His childhood

name was Zenjirō, which was apparently written with varying characters at different times. His father, Ikeda Shigeharu, was a man of many talents—an able calligrapher, a haiku poet, and an adept of the Senke school of the tea ceremony. In 1795, when Eisen was five, he lost his mother, and was brought up thereafter by a stepmother. His relations with this stepmother were excellent, and Eisen seems to have been a good son towards her. In his early childhood, it seems, he was already studying painting, under Kanō Hakkeisai, a pupil of Kanō Eisen. It was doubtless in this period that he was to develop the somewhat stiff style that was to remain with him all his life.

Before long, however, his life underwent a great change. Around the beginning of the Bunka era, at the very beginning of the nineteenth century, he lost, in the summer and autumn of the same year, both his father and his stepmother. He was left with three younger sisters to care for, and at one stage entered the service of the shogunate, but fell victim to slander and embarked on the life of a vagrant. Fortunately, he had a connection in the Mizuno family, who took him in and gave him food and shelter, but the way things were going seems not to have pleased him, and eventually he switched to the trade of ukiyo-e artist. The *Zoku Ukiyo-e Ruikō* says that he used the pseudonyms Kokushunrō and Hokutei around this period. The former name is to be found in the *gōkan Hanagumori Haru no Oboroyo*, published in 1816, but the present author, at least, has seen no works using the name Hokutei.

Little is clear about Eisen's activities in the middle of the Bunka era, around 1810, since there are few sources that enable us to tie up popular tradition with actual dates ascertainable by historical research. The illustrations to a *sharebon*, (popular literature centered around the gay quarters), *Yūshi Gogen* of 1808, and a work entitled *Kishō Seishi,* published the following year, are signed by an artist called Shōsen, who is believed to have been Eisen himself. The style and the prose have qualities in common with Eisen's known work, and the attribution seems fairly certain but there is still no final proof; it is puzzling, for example, that the *Zoku Ukiyo-e Ruikō* makes no mention of this pseudonym. Eisen's autobiography says that he studied with Shinoda Kinji, author of *kyōgen* (kabuki libretti), and himself wrote similar works under the name Chiyoda Saiichi. Two scholars, Hashiguchi Goyō and Ozaki Kyūya, have set the date of this episode at around 1812, but it is not clear when another important incident in Eisen's life—his first meeting with the artist Kikugawa Eiji—took place. According to Mr. Ozaki, his first encounter with Eiji occurred around 1810, and he went to live with him in 1813.

The thing that brought the two men together may have been the fact that Eiji had been a pupil of Kanō Tōsha, while Eisen himself had also studied the style of the Kanō school. Either way, it seems certain that his acquaintance with the Kikugawa family lay down the course that Eisen's *bijin-ga* were to take in the

years to come. Eiji's son Eizan had been doing *bijin-ga* in the style of Utamaro since the beginning of the Bunka era, and had made something of a reputation for himself in the field. Eisen must have known this Eizan too; in fact, early *bijin-ga* by Eisen such as *Ryōgoku Yūsuzumi no Zu* ("Enjoying the Cool of Evening at Ryōgoku") and *Ukiyo Sugata Bijin Awase* show an obvious influence from the latter's style. On one occasion, a certain Lord Hosokawa commissioned pictures from all of Eizan's pupils, and Eisen submitted a work along with them under the name Eisen; this, according to a passage in the autobiographical note, was the reason why he, too, came to be considered a pupil of Eizan's. The text, however, is not very clear here, and another theory considers that he was, in fact, Eizan's pupil. Only three years separated the two men in terms of age, however, and it seems more likely that they were no more than acquaintances.

It was around this time that Eisen's true artistic activity began. His first published work of any kind is considered to have been the *sharebon* signed Shōsen already mentioned above. Following this, he seems to have done other work at sporadic intervals; for example, there is a pornographic work signed Inransai dating from the late Bunka era (the late 1810's) that is believed to be by Eisen. Nevertheless, the earliest work signed unequivocally with the name Eisen would seem to be the *gōkan Hanagumori Haru no Oboroyo* of 1816 mentioned above, for which he did both pictures and text. This work was long supposed to have been published under the name of Ippitsuan Kakō, but the original work quite clearly gives the name Keisai Eisen, and a later version of the same work has, on the cover, "Pictures and Text by Kokushunrō Eisen," with no sign of the name Ippitsuan. The pictures themselves include many likenesses of well-known actors done in a stiff style and with an exaggeration that somewhat calls to mind the work of Yanagawa Shigenobu. The signature Ippitsuan Kakō just mentioned appears soon after this, on a *ninjōbon* (another form of popular literature of the day) entitled *Matsu no Misao Monogatari*, written and illustrated by Eisen. The *Ukiyo-e Ruikō* speaks of Eisen's indebtedness to Hokusai, and it is a fact that in illustrated books published in this period, the human figures and their postures, as well as the animals and plants, frequently suggest an inspiration from—if not a direct imitation of—the older master.

Like every ambitious artist who has yet to achieve a stable reputation, Eisen seems to have had times when he drifted indecisively among various artistic styles. We have it on the *Ukiyo-e Ruikō's* authority that he had always admired the Chinese painting of the Sung and Ming dynasties, and that as we have seen, he admired Hokusai. This admiration for Hokusai may also have led him to adopt elements from the style of Yanagawa Shigenobu, who belonged to the same artistic line. The line and the brushwork, and the degree of exaggeration in the facial features, in Eisen's prints of actors—which are something of a rarity in his output and were published around the beginning of the Bunsei era (1818-1830)—

recall Shigenobu's work, which is a kind of blend of Hokusai-type line with Utagawa-type faces.

These actor prints, incidentally, together with the pictures of actors in illustrations to *gōkan* on kabuki themes, contradict the *Ukiyo-e Ruikō's* assertion that "He did not do actor pictures, apparently considering them beneath the dignity of the ukiyo-e artist." It is true, nevertheless, that his actor prints are very rare—only four of them are known to us today. The reason was almost certainly that Eisen realized the fruitlessness of attempting to compete with the Utagawa school, which dominated the field of the actor-picture at the time. He himself seems to have realized the weakness of his own efforts. In the preface to a somewhat later work, *Kakitsubata Yukari no Nidozaki* (1828)—said to be by Iwai Kumesaburō the actor, but actually done for him by Eisen—he confesses to his own sense of inadequacy in this type of art, and it may well have been this that persuaded him to concentrate almost exclusively on the *bijin-ga* and to evolve some new style of his own in this particular sphere.

The true Eisen-style *bijin-ga* put in its first appearance around 1821. To see what kind of change occurred, one has only to compare, for example, the *gōkan Tōka Ryūsui* of 1821 with the *gōkan Sato no Hana Yuki no Shiromuku* of 1822. The romantic, idealized type of face derived from Eizan gradually gives way to a type of face that is more tense, more alive, and in this sense more realistic. Still more noticeable is the difference in the line. The flexible, curving lines that Eizan had favored gradually give way to straight lines with marked variations in strength and thickness, and to sharp angles that combine with each other to build up the outlines of the figures. This style, which becomes increasingly marked in his later life, has been attributed with great plausibility to some quality in the actual women who lived under the feudal yoke of the Tokugawa regime. But it also seems likely that as the ukiyo-e became increasingly a subject for mass production, the style proved very convenient in speeding up the carving of the blocks.

Whatever the truth, the style was undoubtedly effective in giving expression to the strong-minded, vivacious type of beauty favored at the end of the Edo period. Among the best works that illustrate this new style are *Shin Yoshiwara Hakkei* ("Eight Scenes in the New Yoshiwara"), *Ukiyo Sugata Yoshiwara Taizen*, *Yoshiwara Yōji*, and *Gorishō Musubu no Ennichi*, all of which clearly demonstrate the vigor and technical skill of Eisen in this period. Even at this early date, however, the tendency to overcrowd is apparent. The insistence on fine detail shown, for example, in the elaborate insets to the prints aggravates the somewhat overbearing, cloying atmosphere in the treatment of the women as such.

These standing figures of women enabled Eisen to work out his own style and also, doubtless, to establish his reputation as an artist. As a next stage, from 1822–1823 on, he began to concentrate on the production of *ōkubi-e* (half-length portraits) instead. It was as though the form with which Utamaro and the pupils of

Eishi had achieved so much in the Kansei era suddenly enjoyed a late flowering in the Bunsei era. However, where Utamaro and his colleagues had pursued an ideal of willowy, elegant, stylized beauty, Eisen's concern was to give direct expression using his own idiosyncratic sense of form to something—certain aspects of the female psychology, one might almost say—that he sensed beneath the surface of his women. In the great series advertising the cosmetic *Sennyokō*—*Ukiyo Fūzoku Mime Kurabe, Bijin Kaichū Kagami, Imayō Bijin Jūnikei* among them—he employs this manner to convey an almost oppressive sense of femininity and sensual actuality. Every element that makes up the faces of these women—the long, slanting eyes that do not quite match each other, the slightly impatient contraction of the eyebrows, the half-open, slightly pouting lips with the touch of green to suggest an iridescent sheen on the lower lip—reveals the subtlety of his observation of the opposite sex. These *ōkubi-e* are the embodiment of all that is coquettish and sensual in the feminine makeup; it is small wonder that his beauties have been referred to as the "harlot type." Both qualitatively and quantitatively, Eisen's *ōkubi-e* of women are unrivaled by any other late ukiyo-e artist.

There are indications that at some time around this period Eisen did illustrative work in which he sought to match the sensual descriptions common in the *ninjōbon* popular at the time, as well as erotic books that he himself wrote under the name of Insai Hakusui. It was this type of work, doubtless, that prepared him for the achievement of the single-sheet *ōkubi-e* prints.

Sometime between the middle and end of the Bunsei era, Eisen abandoned the *ōkubi-e* and began once more to produce large numbers of full-length pictures of women. Outstanding among them are *Keisei Dōchū Sugoroku, Shin Yoshiwara Nenjū Gyōji* ("Round the Year in the New Yoshiwara"), and other works inspired by the Yoshiwara gay quarters. However, from around this time on his work begins to show signs of stereotyping and stagnation. The one innovation is the great attention that he began to pay to the detail of the dress—the patterns on the kimono, for instance—of his courtesans. It is obvious that he put a good deal of thought into giving variety to his prints in this way. For all their elaborateness, however, these works inspired by the Yoshiwara give less evidence of Eisen's true quality as an ukiyo-e artist than works such as *Ukiyo Bijin Jūnikagetsu* and *Tōsei Meibutsu Kanoko* that show scenes from the everyday life of the merchant class and are believed to be of later date.

Another interesting series from around the same period is the *Oiranda Kagami* (the "Oiranda" is a play on the words *oiran*, "courtesan," and *Oranda*, "Holland"). The most striking characteristic of this work is the use of fine parallel lines for shading, in the manner of Dutch etchings, in the landscape scenes in insets that accompany the pictures of the women. Not only in such prints but also in, for example, the cover to the *gōkan Inu Chomon Keisei Kagami* of 1827, Eisen makes use of Western-style techniques, in which he seems to have been partic-

ularly interested at this period. The few surviving landscapes by Eisen with borders of foreign lettering may well have been produced around the same time.

Around the end of the Bunsei era, Eisen's attention was attracted to a type of synthetic blue pigment brought in from abroad and known popularly in Japanese as *berorin*, used to produce landscapes employing the *aizuri* technique. A contemporary essay mentions that the foreign pigment was first used for prints in 1829. "A fan wholesaler, Iseya Sōbei, started selling fans," it says, "with a Chinese-style landscape on one side and a scene on the Sumida River on the other, both done by the artist Keisai Eisen (pupil of Eizan) and printed in varying shades of blue. They proved immensely popular, and many other fan merchants also began to sell fans done in the same *aizuri* technique." The *Zoku Ukiyo-e Ruikō* also says: "The recent vogue for color prints done in *aizuri* was originated by this man (Eisen)," and it seems fairly safe to attribute the invention of *aizuri* to him. In fact, the cover of a *gōkan* entitled *Benie-uri Mukashi Fūzoku* published as early as 1829—the year that the technique is supposed to have first been used—provides an actual example of the technique, which is used for the landscape that forms one part of the pictures. Eisen may have taken the hint from the pictorial patterns in varying shades of dark blue that were used on some ceramics, but so varied was his talent that it seems quite likely that he should have hit on the idea on his own. This particular type of coloring, with its oddly *fin-de-siècle* (*fin d'époque* would be more accurate), sensational effect was most suitable for Eisen's works, which contained elements appealing very directly to the senses.

It was just now, when Eisen's artistic career had entered on a new stage, that trouble occurred in his personal life. Around the beginning of the 1830's he moved to Nezu, where he established a brothel called Wakatake-ya. Before long, however, it was destroyed by fire, then Eisen himself was forced to abscond when it was discovered that he had misappropriated another man's personal seal. The last incident is mentioned in a note appended by the compiler, Saitō Gesshin, at the end of the section on Eisen in the *Zoku Ukiyo-e Ruikō*. It is a fact that there was a sharp drop in the amount of illustrative work Eisen did during the period from early Tempō on into the middle of the era.

In 1835, he embarked on the series "Sixty-nine Stations on the Kiso Highway." In practice, he was to do only twenty-four of the prints in the series, all the rest being the work of Hiroshige. It is still not clear why artists should have been switched in midstream; possibly the irregularity of Eisen's personal conduct was too much for his publishers. Either way, the work itself is of quite a high level, and ranks among the more interesting of Eisen's landscapes.

The *bijin-ga* that had always been his main interest and the type of landscape seen in the "Sixty-nine Stations" join hands in the major work of his last years, the "Beautiful Women of the Fifty-three Stations" (a conjectural title, since no series title appears on the prints themselves). Each of the prints shows a full length

portrait of a woman in the foreground, with a landscape in the background occupying roughly one-half of the total space. Works known to survive from the series include a picture of a beauty washing her neck at "The Ōiso Station," and a woman shaving at "The Inn at Numazu."

Eisen, as did everybody else, suffered from the effects of the Tempō reforms, the same restrictions on subject matter and use of color applying to his works as to those of other ukiyo-e artists. It was almost certainly at this period that he started adapting blocks originally carved for earlier works and republishing the works as *aizuri* prints. There is a certain rich, sensual quality about the *aizuri* effect that makes it particularly suitable to Eisen's earlier prints.

From the time of the Tempō reforms on, Eisen came increasingly to devote himself to writing. We have some prints from the Kōka era, of course, such as the picture of the Kegon Falls, but by the end of the era his chief occupation was the writing of popular novelettes. The *gōkan Sono Yukari Hina no Omokage* and *Jiraiya Gōketsu Monogatari*, as well as various *kokkeibon* (fragmentary tales and dialogues of Edo low life), bear witness to his skill in this field. He also published works such as *Fūgai Koseki Kō*, a kind of map showing historical sites, and *Kakusen Zukō*. His talent, thus, was branching out in new directions even at this late date, but before he could make any special mark in these new fields he died, on the twenty-second day of the seventh month, 1848. He was fifty-eight.

His deathbed poem, as quoted in a work on the lives of the popular authors of the day, runs, roughly translated, as follows: "As I ascend to the brilliant, many-hued clouds of Paradise, there is not a single shadow on my heart." The sentiment is admirable; but in the Japanese original there are plays on words and references to the artist's world ("shadow," for example, can also mean "shading" in the technical sense) that show how to the very end Eisen remained a typical artist, and a typical man of his wholly unique period.

<div style="text-align: right">Jūzō Suzuki</div>